BRAVEST

YORK CITY THANKS YOU
COURAGE AND YOUR B
UR TIME OF NEED, AN
OU RISK YOUR LIFE F

BRAVERY RESEMBLES
NGL IN THE EYES O
TMS TO DEVASTATIC
ALL IN THE LINE

ORK CITY'S BRAVEST
OWN AS NEW YORK

ANGELS

Lamentation 9/11

Text by **E. L. DOCTOROW**
Preface by **KOFI ANNAN**
Photographs by **DAVID FINN**

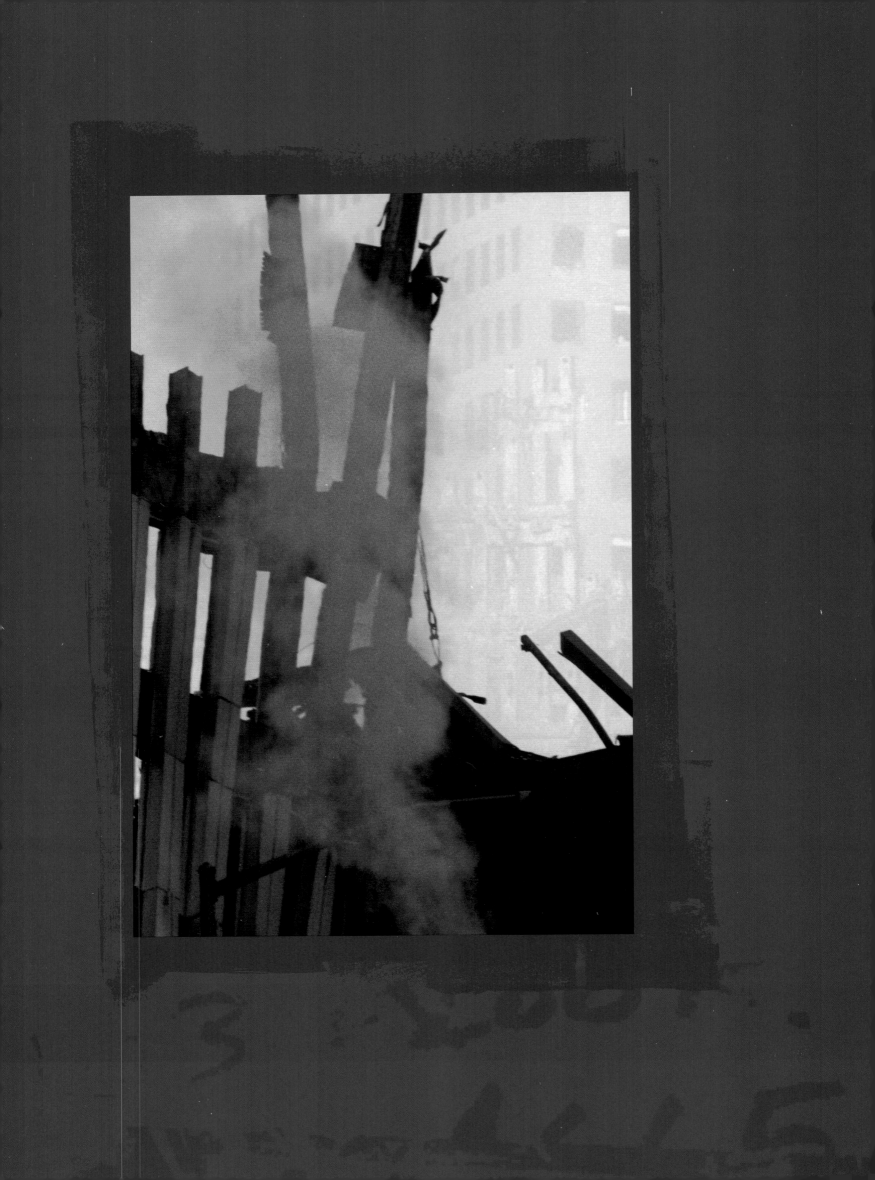

Preface

The vicious acts that were perpetrated on 11 September were an attack on humanity itself. New York was struck by a blow so deliberate, malicious and destructive, that we are still struggling to grasp its significance. We were astonished by the evil in our midst and dazed by the disregard for human life. Our souls were shaken.

On that day, the United Nations grieved with other New Yorkers at the gaping wound that had been inflicted on this wonderful city — this city that has been such a warm and welcoming host to us for five decades. We felt a deep bond of solidarity with all Americans in our shared hour of trial.

We mourned the deaths of so many valiant fire fighters, police officers and other emergency workers who lost their lives in the tragedy and in the rescue and recovery efforts — people to whom we in the UN owe a special debt of gratitude for their work to keep us safe over the years. We mourned the deaths of people from many of our Member States, in addition to those of the Americans who perished. We mourned an attack on our shared values.

Terrorism strikes at the very heart of everything the United Nations stands for. It presents a global threat to democracy, the rule of law, human

ights and stability. All nations of the world must renew efforts to eradicate terrorism from the face of the earth.

After a season of savage loss, let us now sustain our resolve to unite against the forces of darkness and rededicate ourselves to the cause of peace. Let us reassert the freedom of people from every faith, culture and nation to meet, mingle and exchange ideas and knowledge in mutual respect and tolerance — the very freedom that New York City symbolizes, more than any other city in the world.

KOFI ANNAN

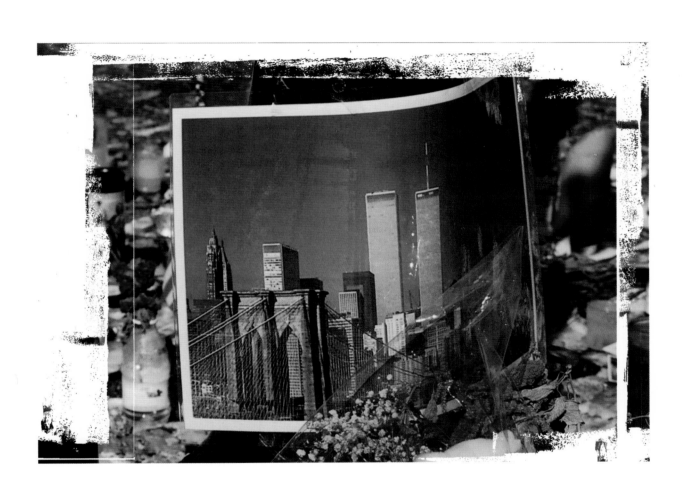

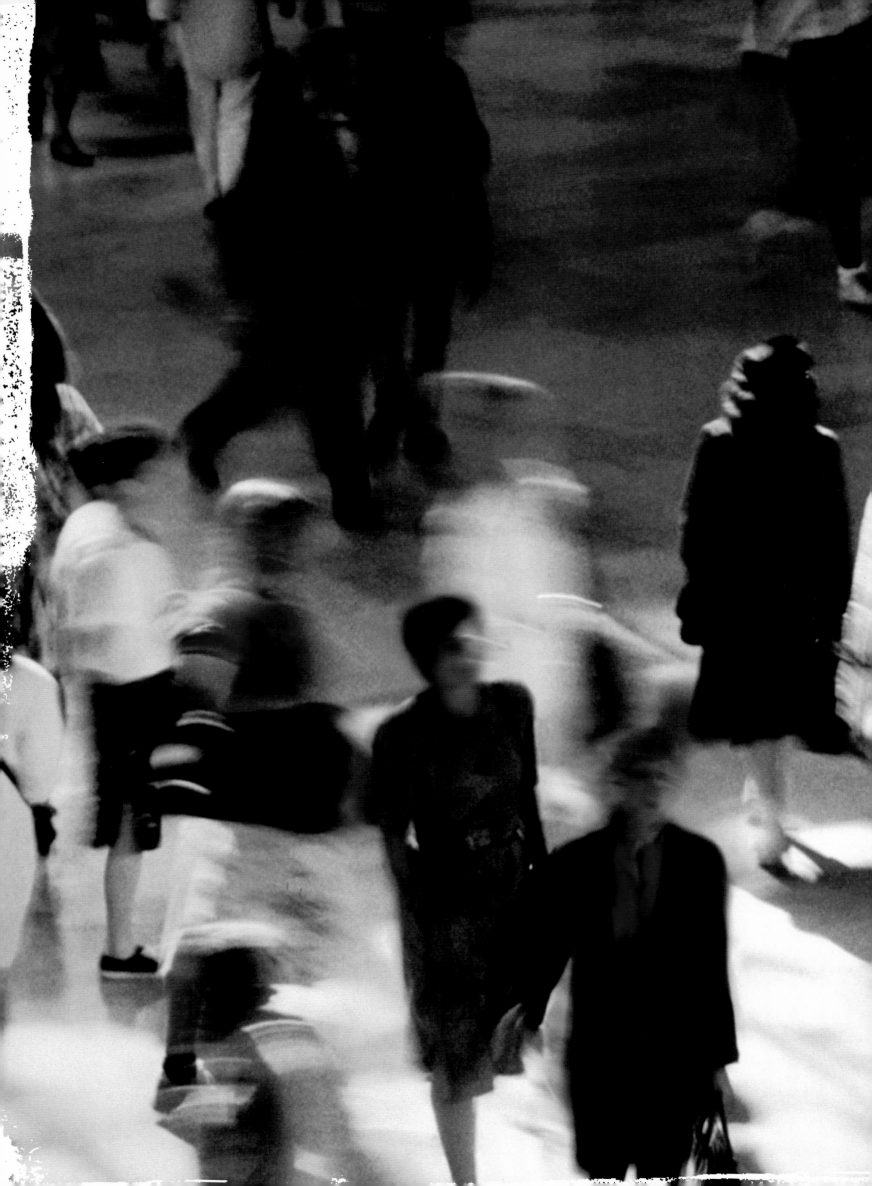

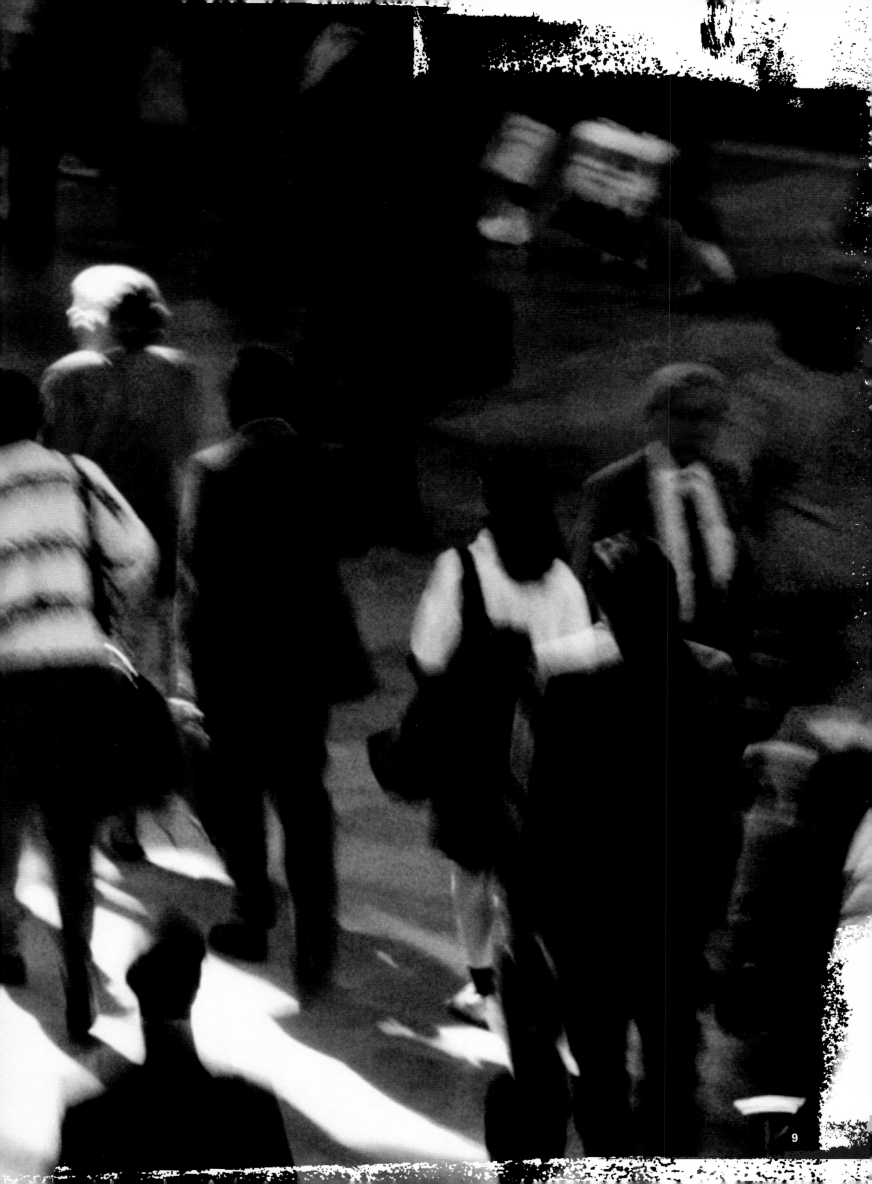

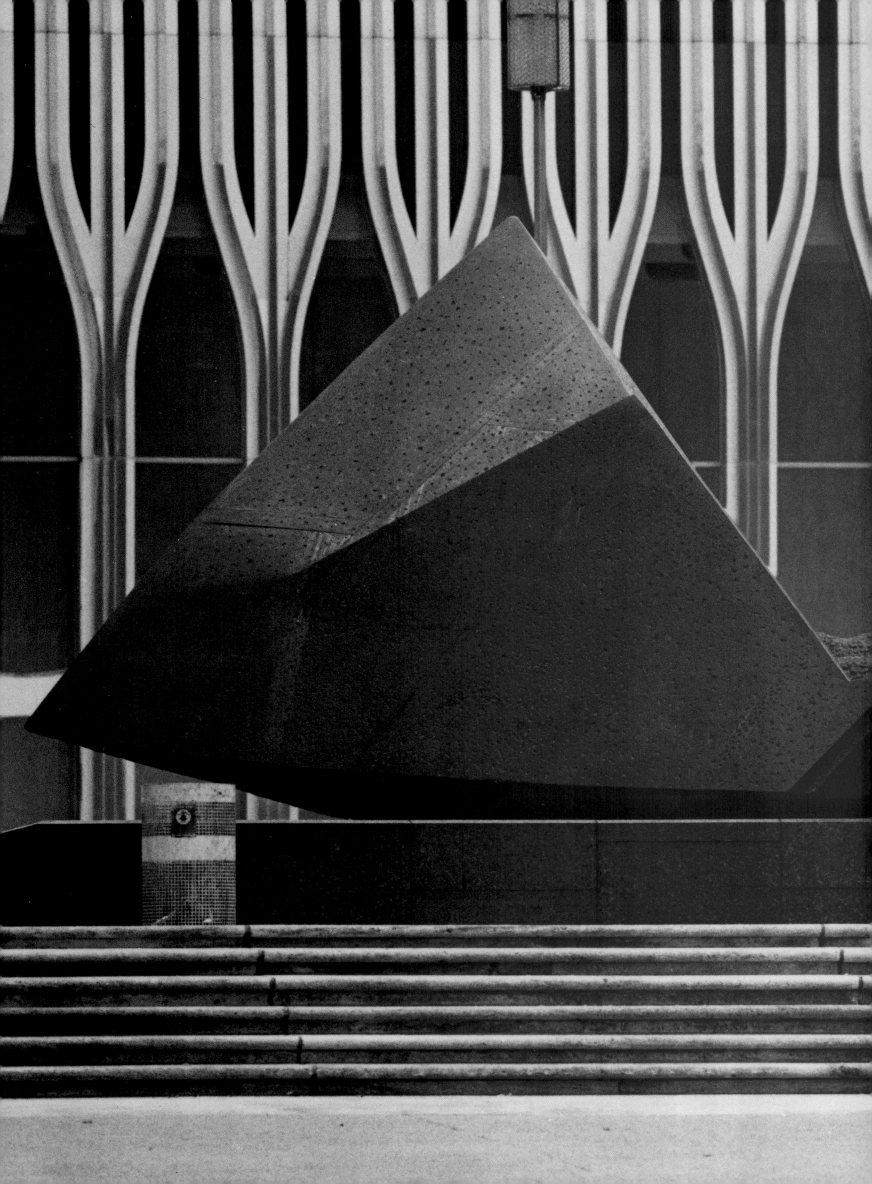

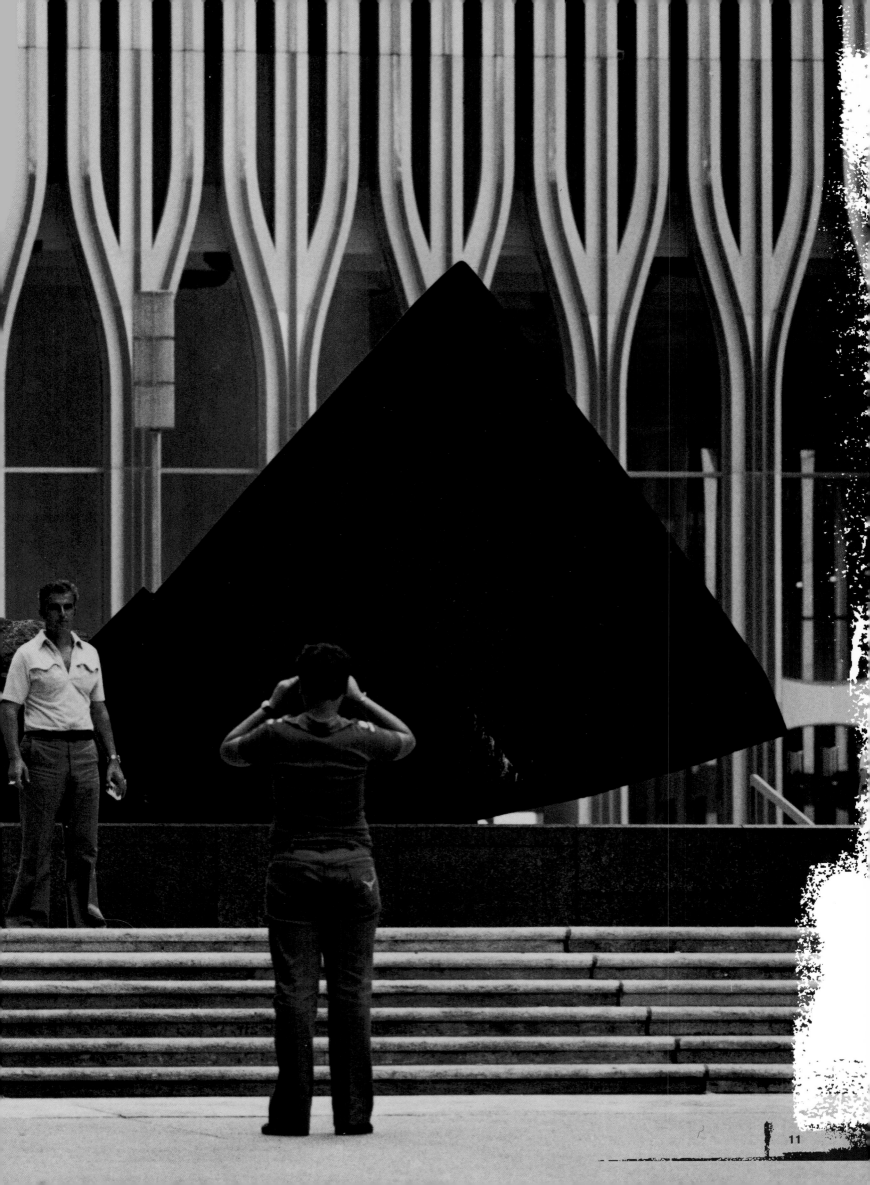

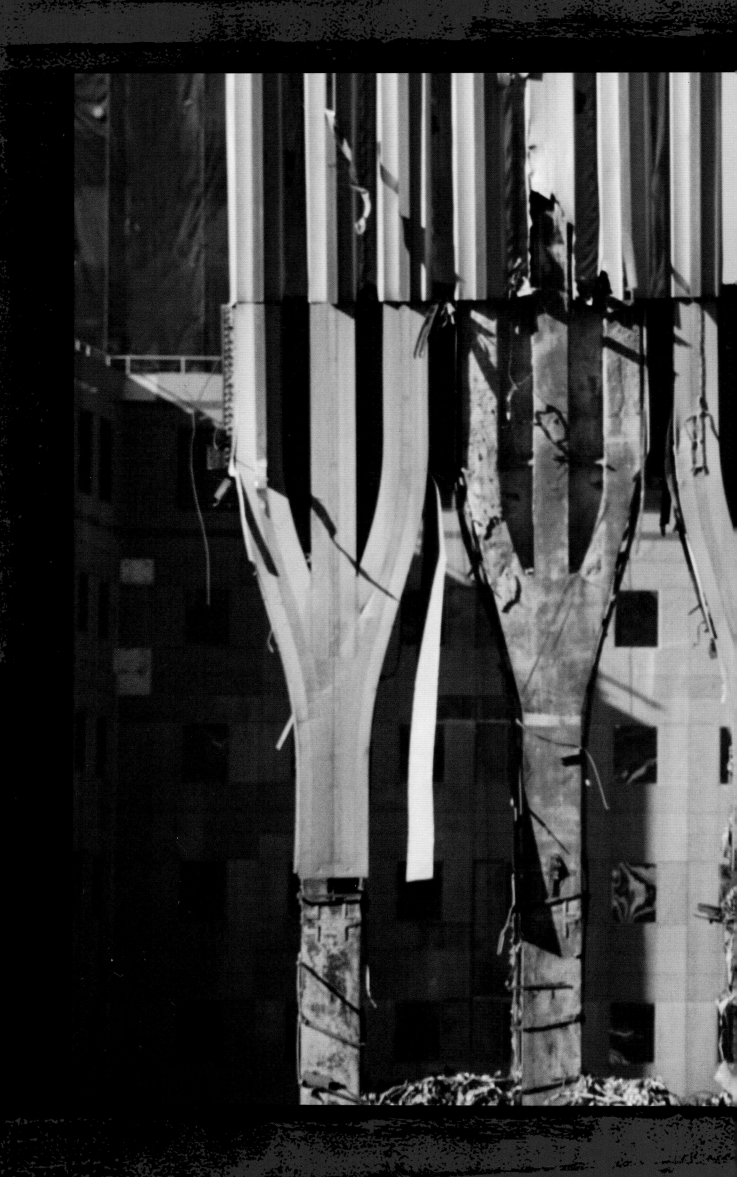

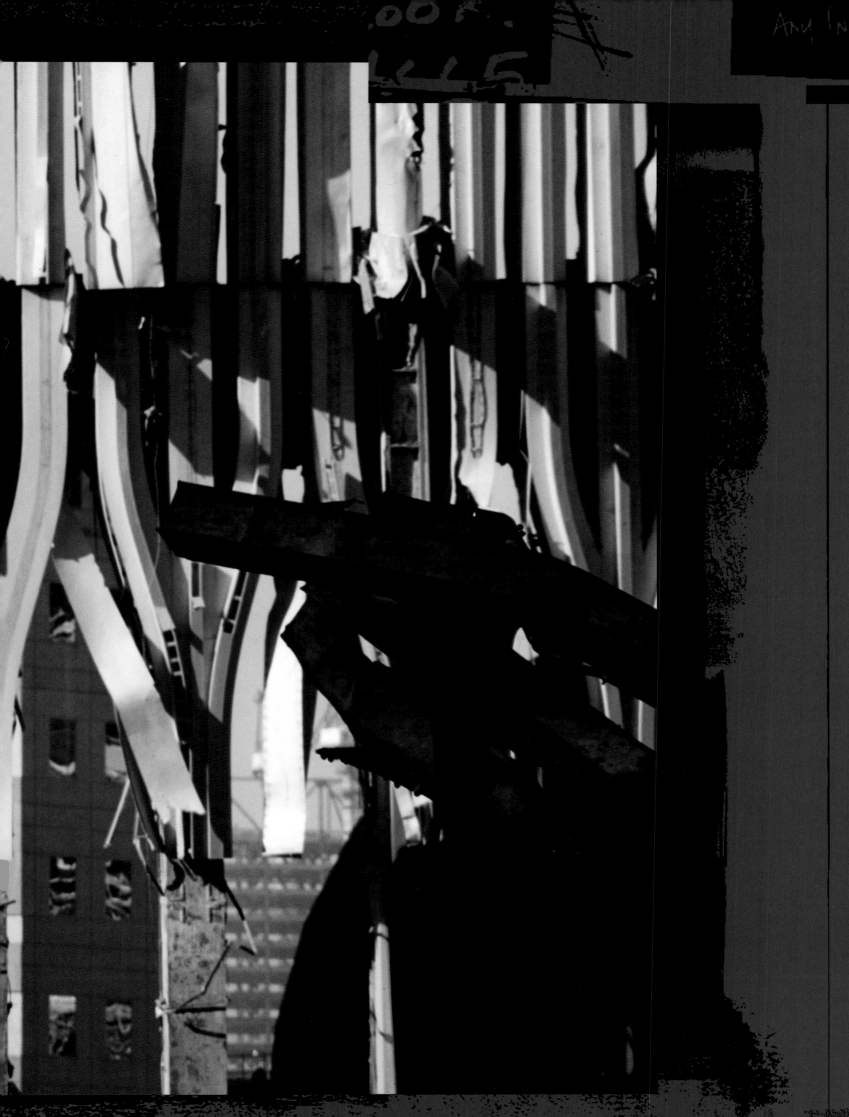

13

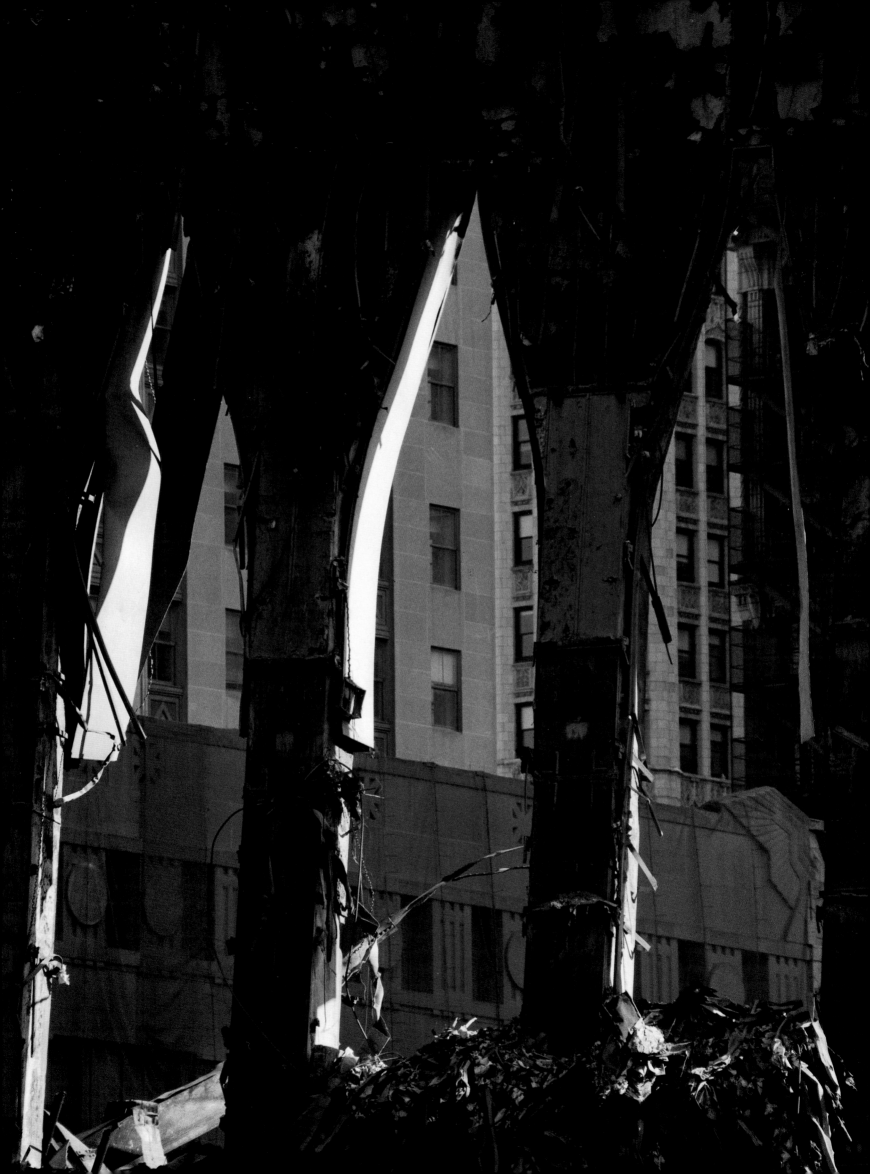

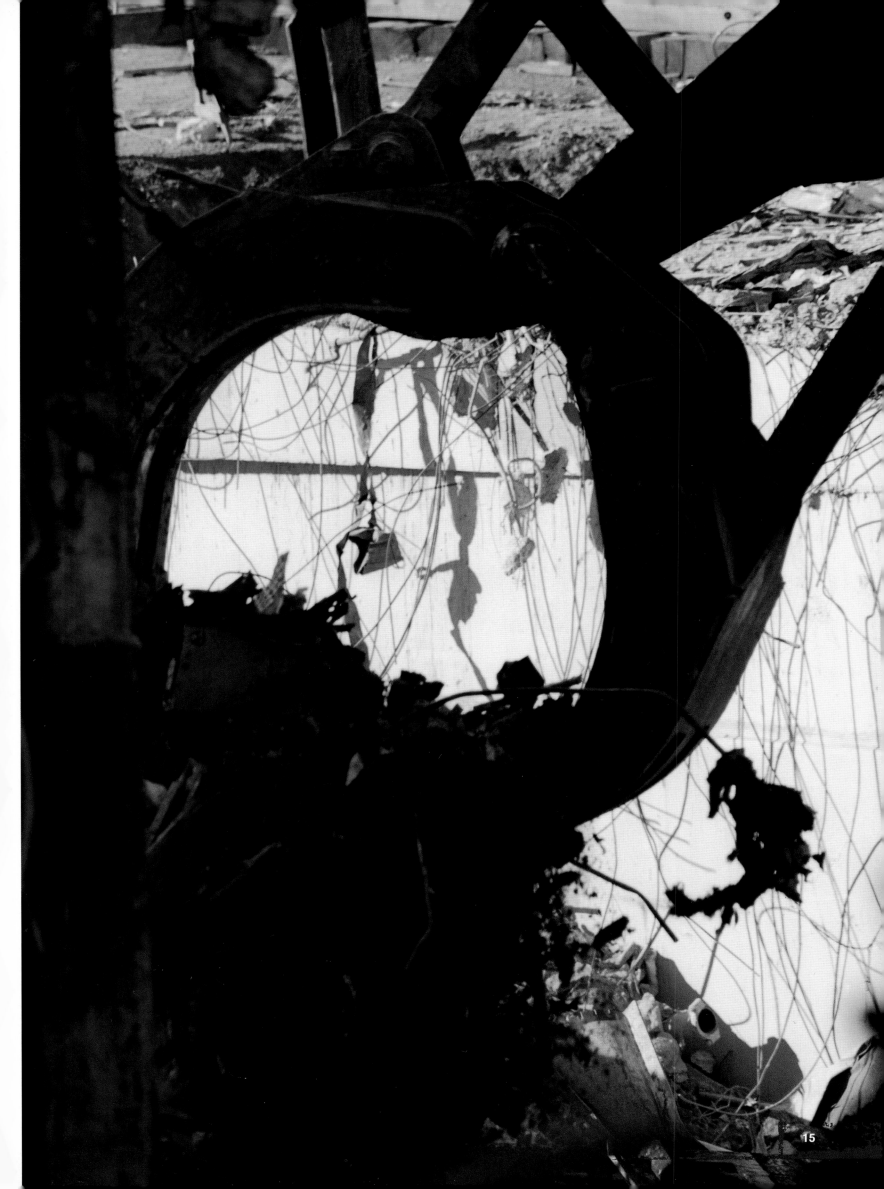

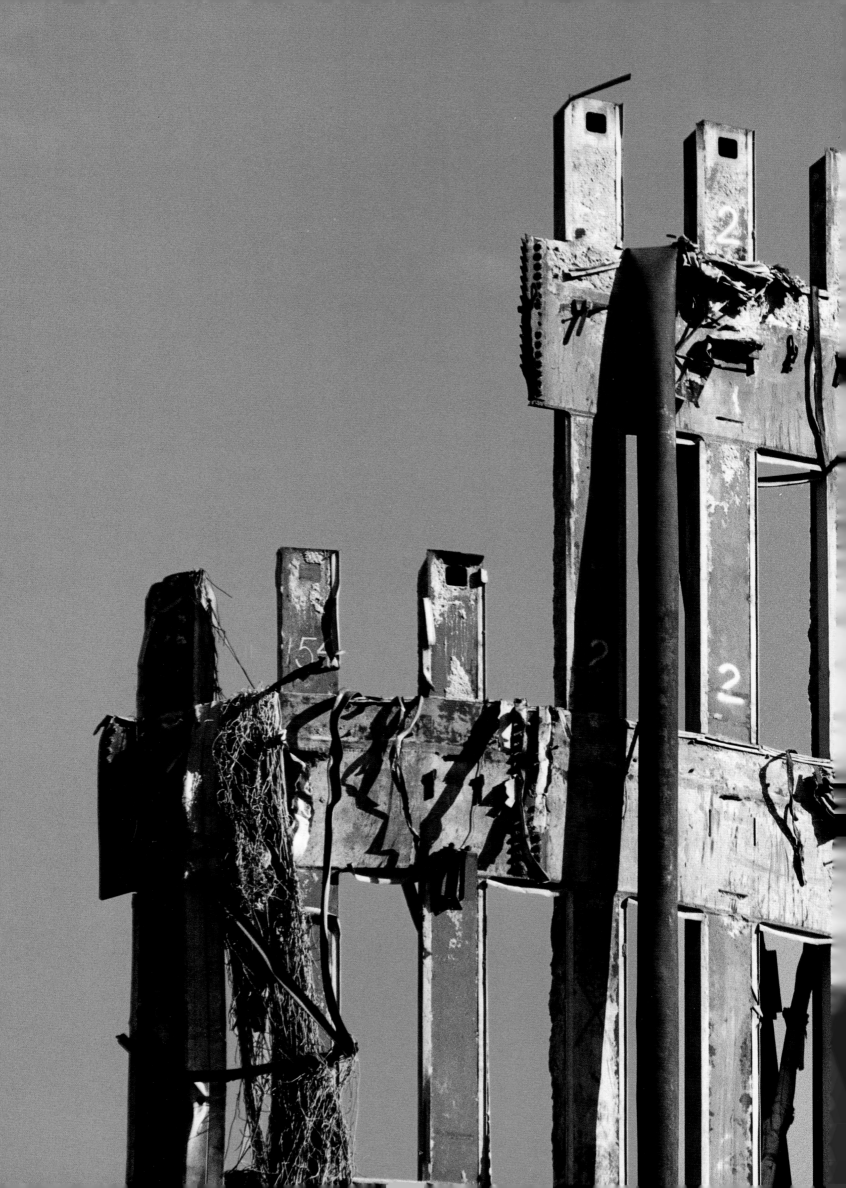

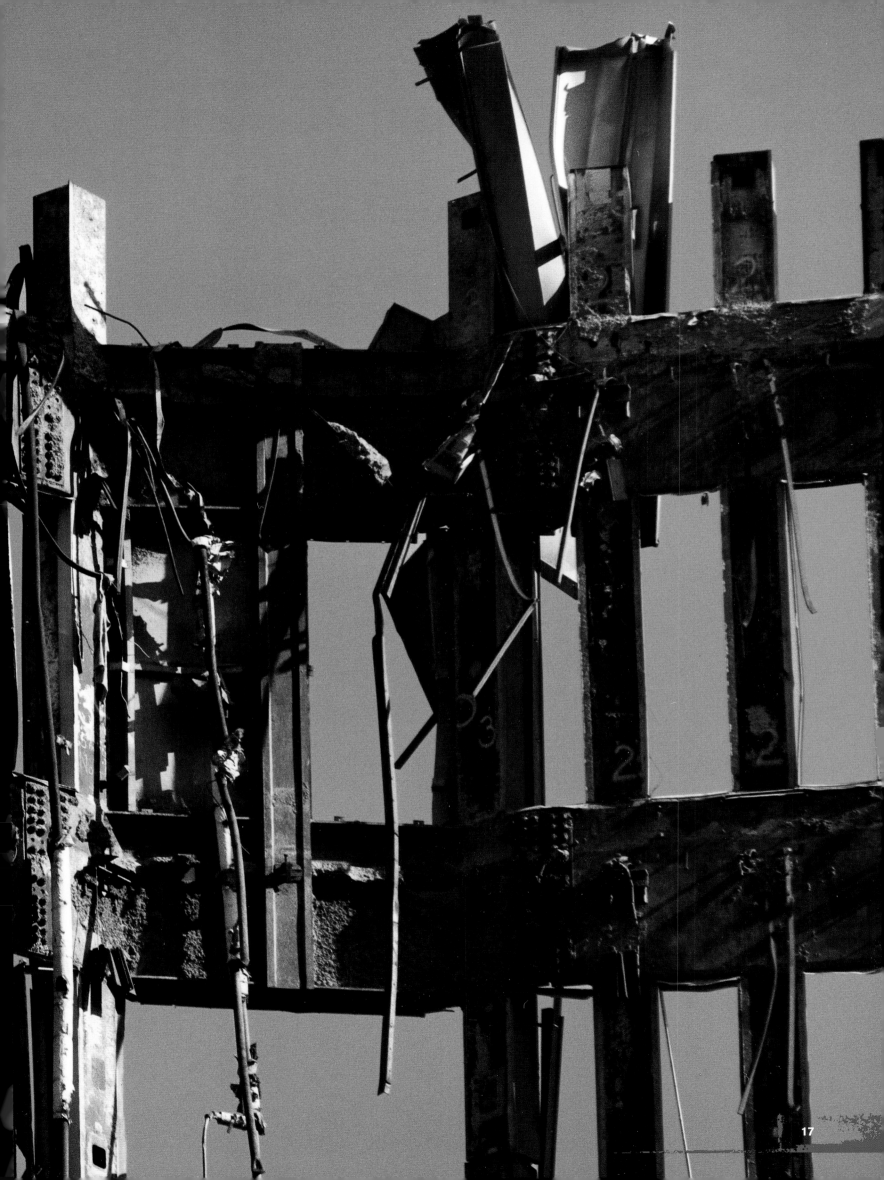

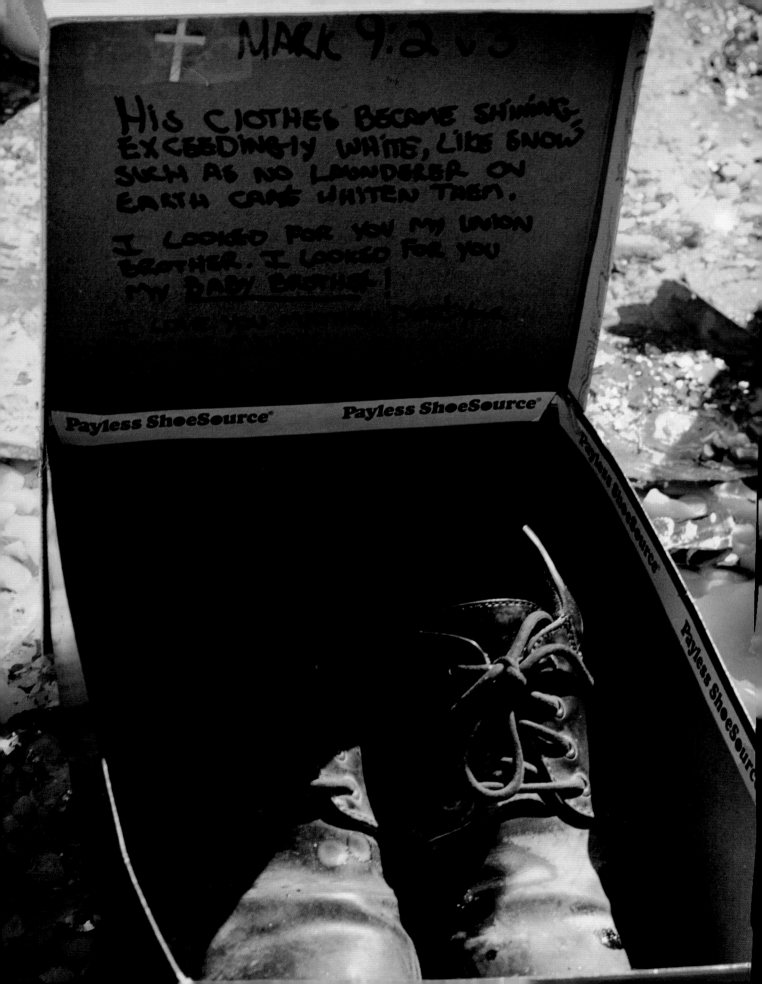

I didn't know them, the people who died there,

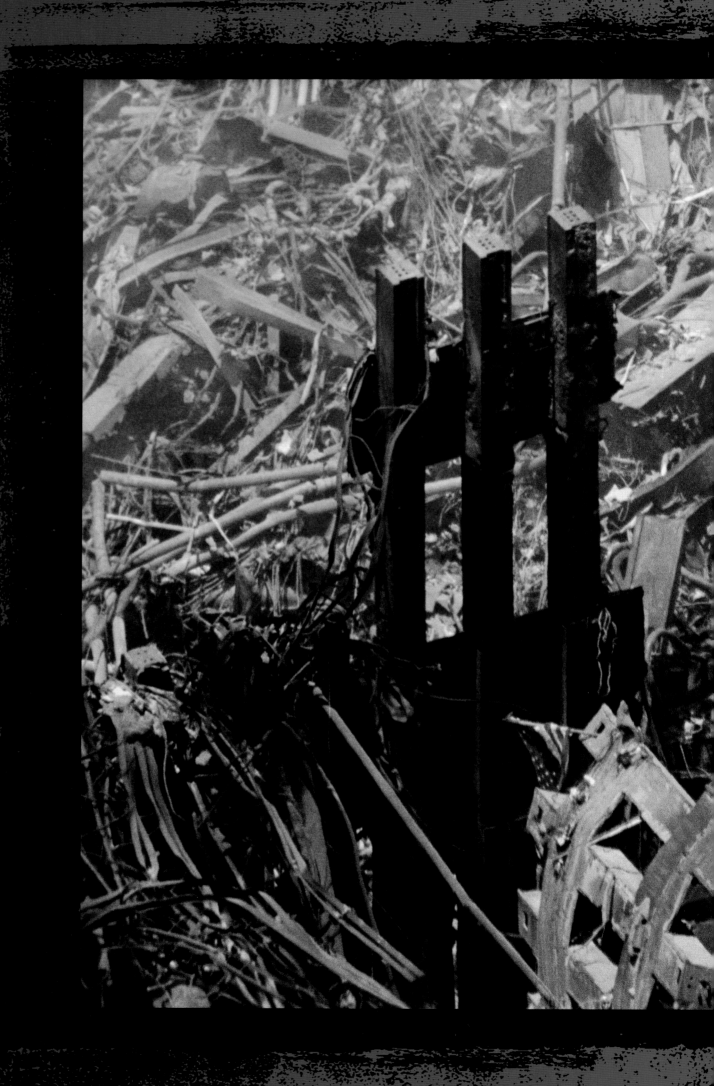

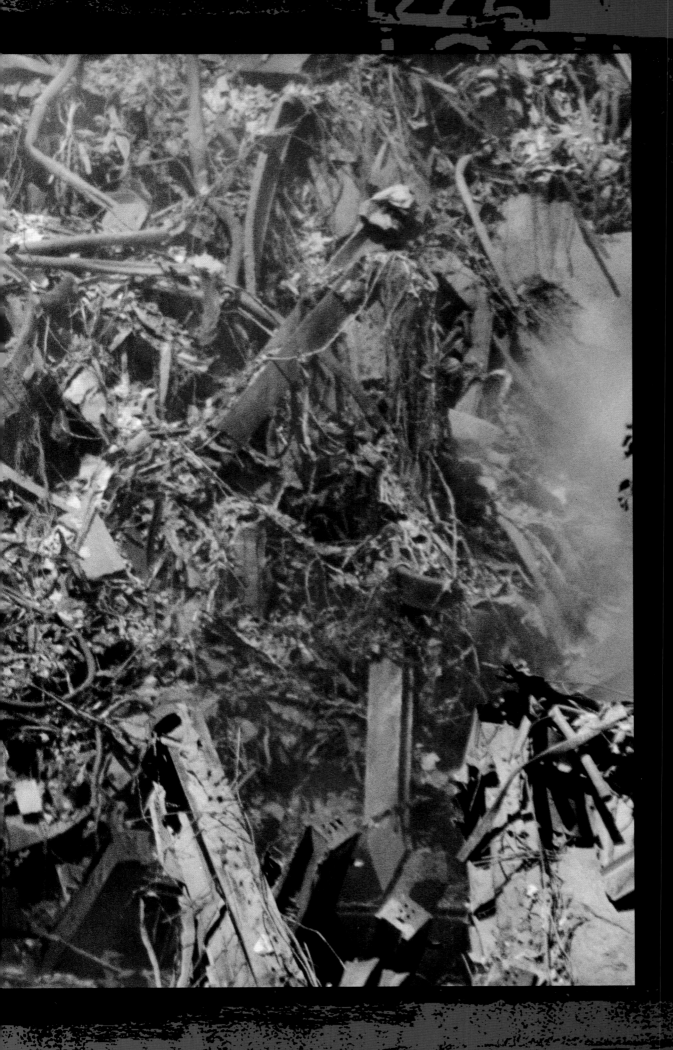

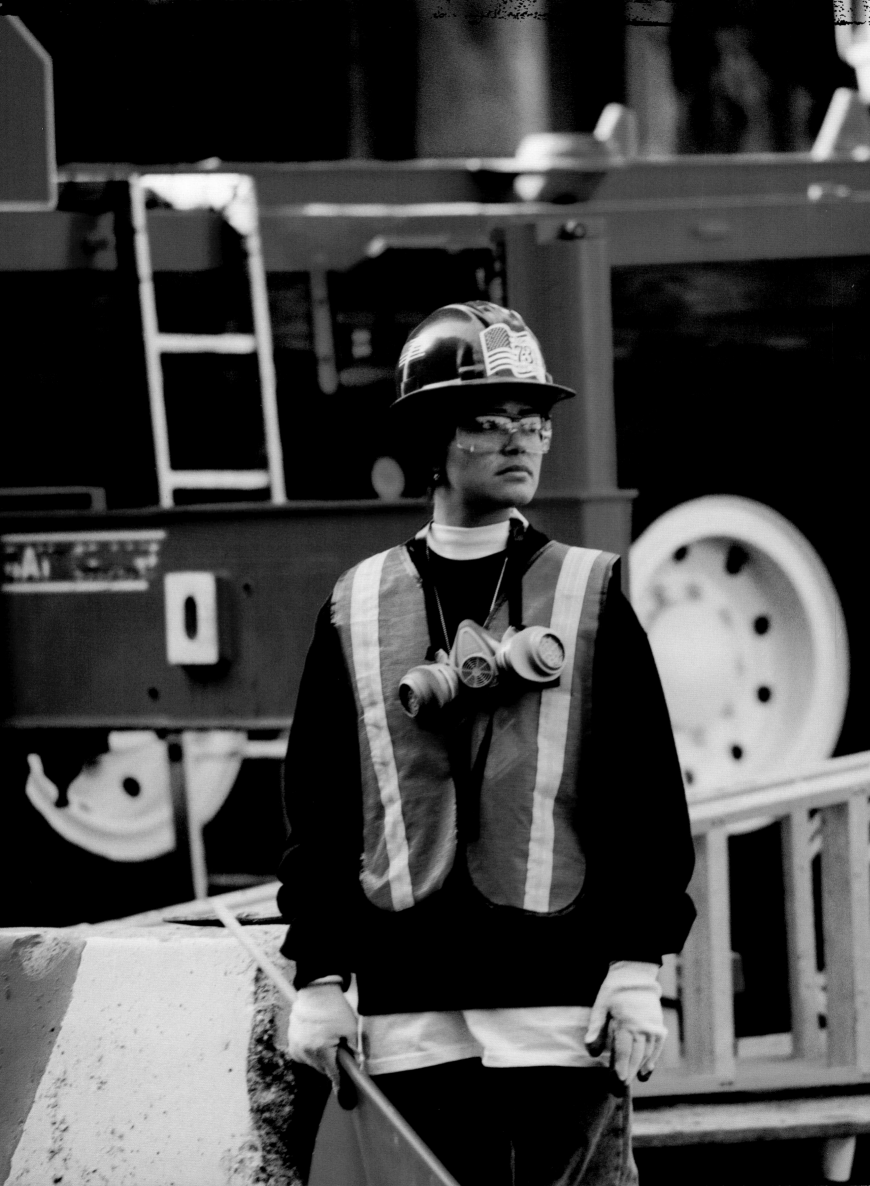

. . . or the people who came to their rescue and died there, the thousands upon thousands of them, I knew them not at a

MISSING

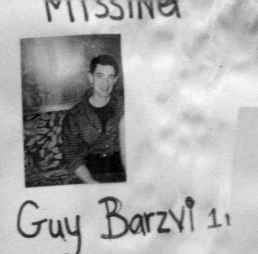

Guy Barzvi 1.

MISSING:

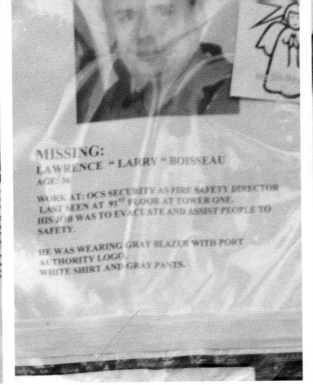

MISSING:
LAWRENCE "LARRY" BOISSEAU
AGE: 36

WORK AT: OCS SECURITY AS FIRE SAFETY DIRECTOR
LAST SEEN AT 91st FLOOR AT TOWER ONE.
HIS JOB WAS TO EVACUATE AND ASSIST PEOPLE TO
SAFETY.

HE WAS WEARING GRAY BLAZER WITH PORT
AUTHORITY LOGO.
WHITE SHIRT AND GRAY PANTS.

MISSING

Michael G. Jacobs

LAST SEEN:

MADETTE BECKLER

COMPANY: Fiduciary Trust Company
BUILDING: Tower #1 95 at 97th floor
Phone contact: 516-118-1995 or 516-170-6736 or 516-464-1193

John Thomas Andreacchio

JEFFREY SHAW 42.

Tattoo shade
Yosh tisant
FATHER OF 2
CANTOR
FITZGERALD
105

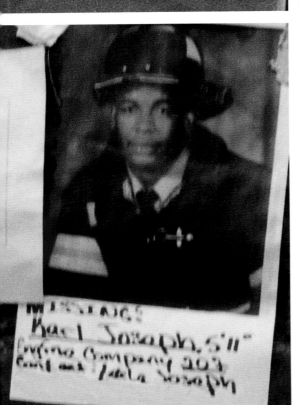

MISSING
Kael Joseph, 5'11"
Engine Company 202

MISSING
PAUL ORTIZ JR.

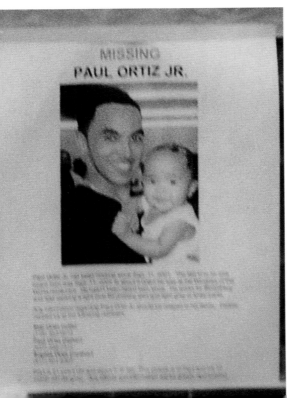

JAKE JAGO...

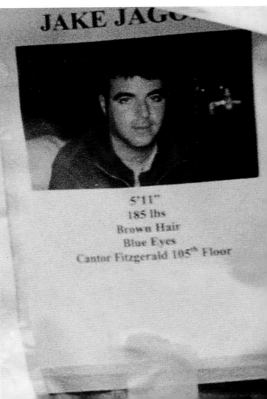

5'11"
185 lbs
Brown Hair
Blue Eyes
Cantor Fitzgerald 105th Floor

MISSING

CRAIG NEIL GIBSON

D.O.B. - Dec. ██ 1963
Age - 37
Height - 5' 11"
Weight - 170-180 lbs
Eyes - green
Hair - lt brown, receding hairline, No. 1 haircut

Features - small scar on forehead, 1"-2" scar between shoulder blades
Clothing - long sleeve blue Ralph Lauren shirt, dark navy trousers, black belt and shoes, silver TAG watch on left wrist, navy blue + silver stripe backpack
Works for - Guy Carpenter/Marsh McClennan, 94th Floor WTC 1

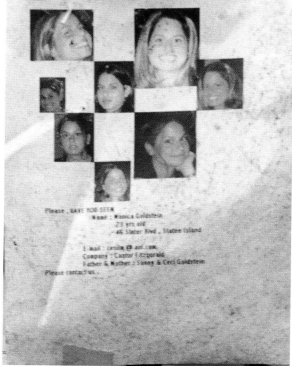

Please . HAVE YOU SEEN
Name : Monica Goldstein
25 yrs old
46 Slater Blvd , Staten Island

E-mail : cecilia @ aol.com.
Company : Cantor Fitzgerald
Father & Mother : Sonny & Ceci Goldstein

Please contact us .

Please, If you have any
Information Call the
New York Fire Department

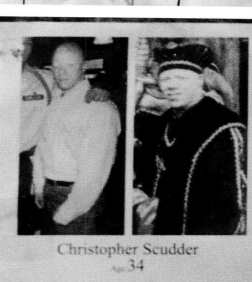

6'2 170lbs Brown Hair
Joe Hunter Brown Eyes
Squad 288
 O Flurion Style
F D N Y around neck

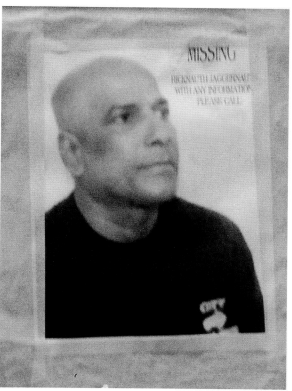

MISSING

BICKNAUTH JAGGERNAUTH
WITH ANY INFORMATION
PLEASE CALL

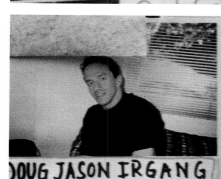

Christopher Scudder
Age 34

Last known location
Tower 2 93rd Floor

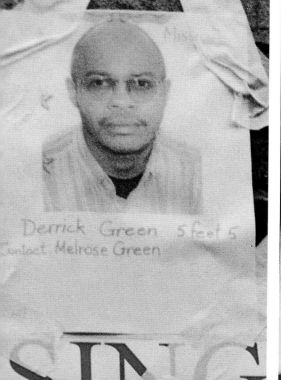

Derrick Green 5 feet 5
Contact Melrose Green

MISSING: RICHARD Y. C. LEE

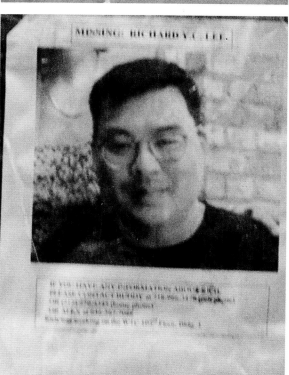

IF YOU HAVE ANY INFORMATION ABOUT
PLEASE CONTACT EDDIE at 718-996-XXXX
Was working on the WTC 102 Floor, Bldg. 1

DOUG JASON IRGANG

AGE: 32 years old
Weight : 140 lbs
Height : 5'8"
Eyes : hazel
Identifying scar on right side of his stomach. (large scar)

LAST SEEN @ 2 WORLD TRADE CENTER
WORKS @ Sandler O'Neil FL 104
IF YOU HAVE ANY INFORMATION
Please contact us....

SING

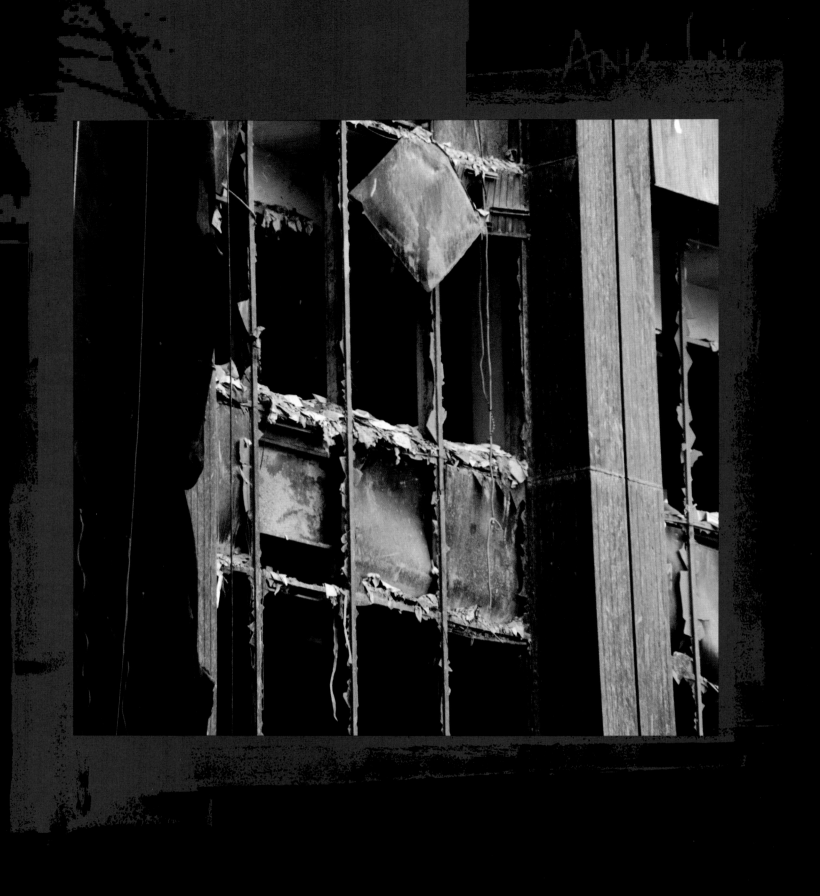

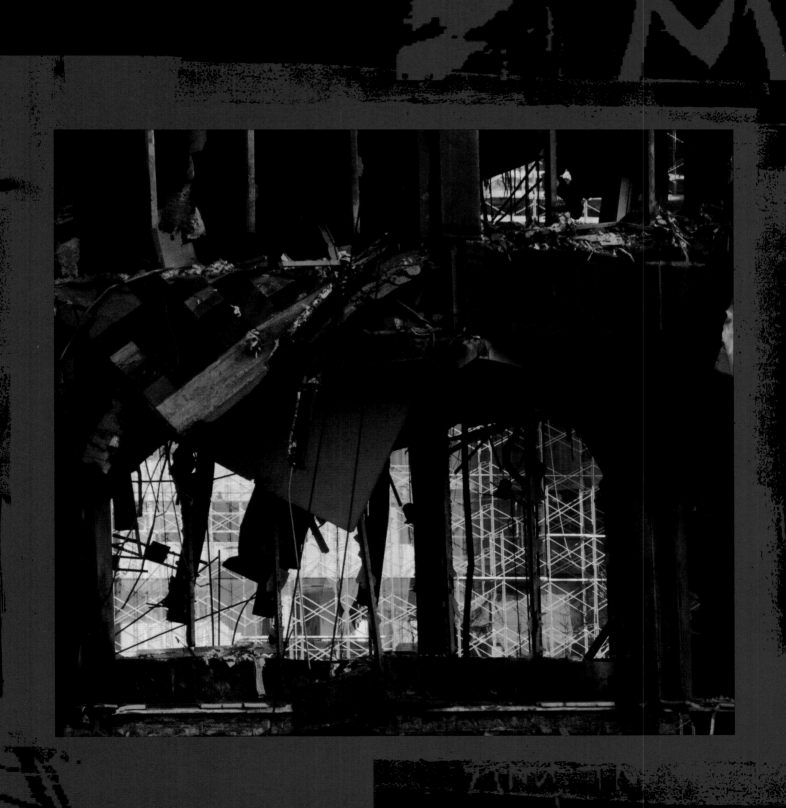

But I counted on them. They were of my city.

edical

uilding

(607) 336-

Missing from World Trade Center Building 1
106th Floor Windows on the World

John F. Puckett

John F. Puckett
24 Titus Road
Glen Cove, NY

Age: 47 dob: 2/2
Height: 63" 175 lbs
General Description: Tall, slender, glasses
Thinning light brown hair, distorted thumb on left hand
Tumor behind right ear. Size 13 shoes
John is assumed to last be seen setting up the
audio for a conference/meeting at
Windows on the World on the 106th floor of Building 1 WTC.
John was wearing a black suit, white shirt & tie.

5'10", 180lbs.
Blue Eyes
Lt. Brown Hair

M
I
S
S
I
N
G

SWEDE CHEVALIER
WTC #1, 104th Floor
CANTOR FITZGERALD

MISSING

John
Chipura

11/27/61
5'10"
265 lbs.

LADDER COMPANY
FDNY 105

Multiple Native American tattoos

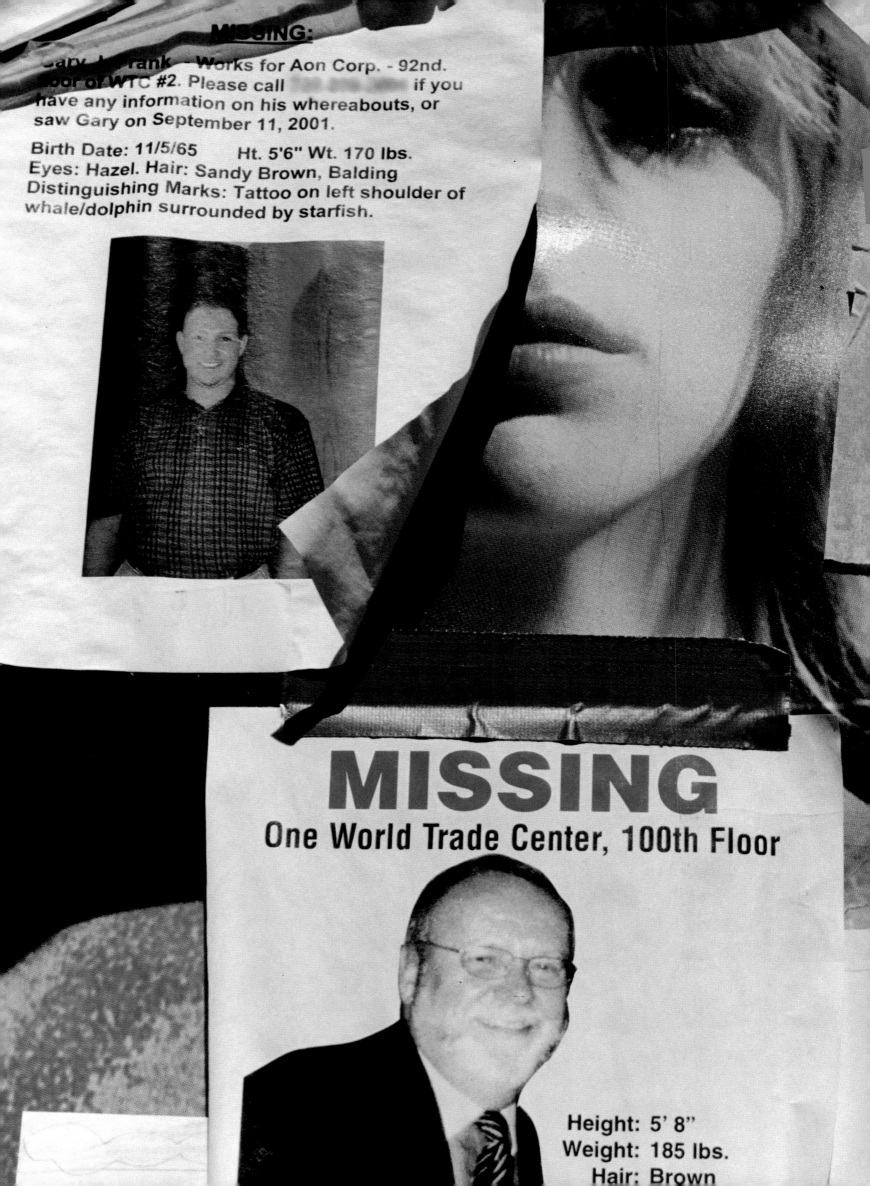

MISSING:

Gary ~~A. Frank~~ - Works for Aon Corp. - 92nd. ~~Floor~~ of WTC #2. Please call [blurred] if you have any information on his whereabouts, or saw Gary on September 11, 2001.

Birth Date: 11/5/65 Ht. 5'6" Wt. 170 lbs.
Eyes: Hazel. Hair: Sandy Brown, Balding
Distinguishing Marks: Tattoo on left shoulder of whale/dolphin surrounded by starfish.

MISSING
One World Trade Center, 100th Floor

Height: 5' 8"
Weight: 185 lbs.
Hair: Brown

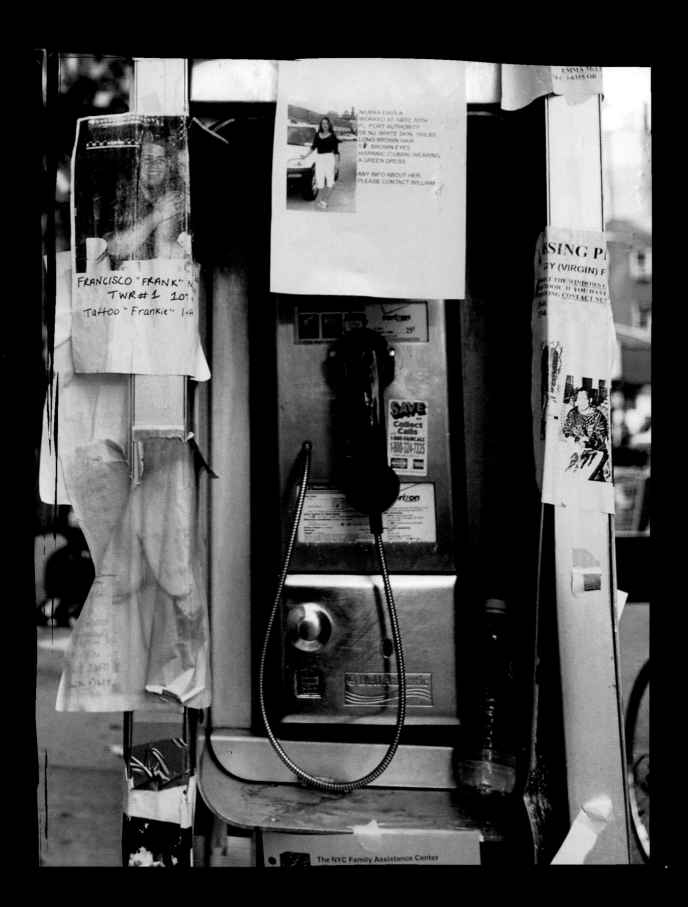

FRANCISCO "FRANK" N
TWR#1 107
Tattoo "Frankie" 14

NURKA DAVILA
WORKED AT 1WTC 70TH
FL. PORT AUTHORITY
OF NJ. WHITE SKIN, 160LBS.
LONG BROWN HAIR
5'? BROWN EYES
HISPANIC (CUBAN) WEARING
A GREEN DRESS

ANY INFO ABOUT HER
PLEASE CONTACT WILLIAM

SING P
CY (VIRGIN) F

The NYC Family Assistance Center

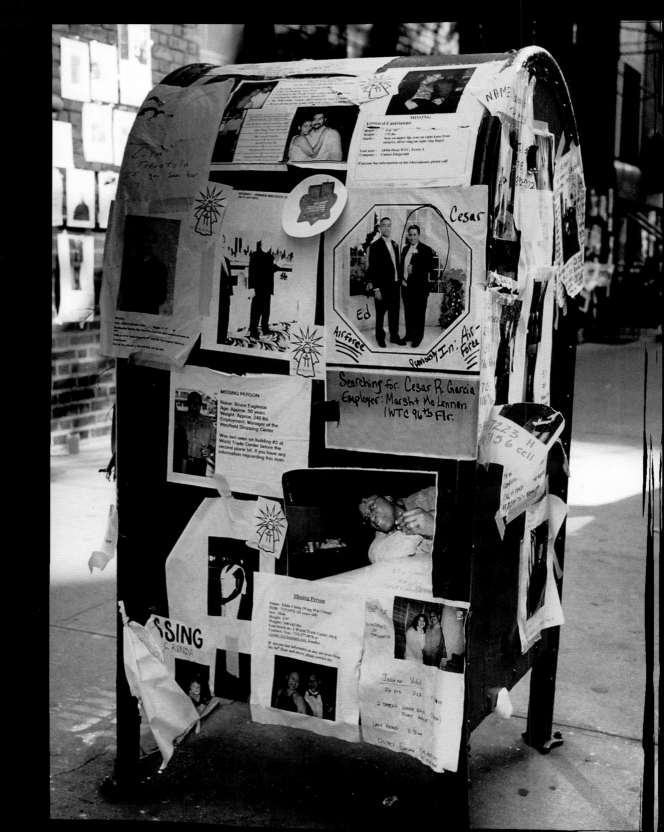

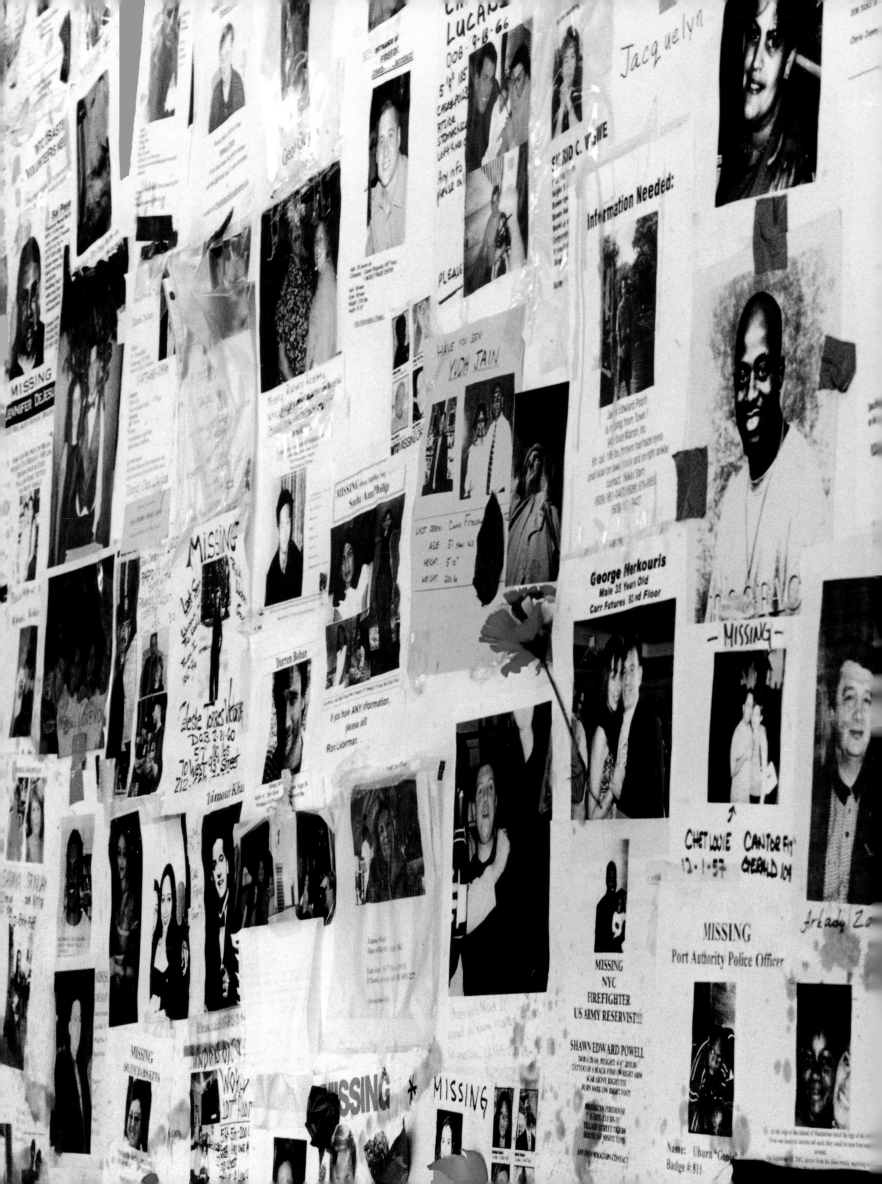

PAUL INNELLA

DOUG JASON IRGANG

Samantha & Lisa Egan

Missing from Cantor Fitzgerald

Please Call: 631-475-9...

MISSING

DEBB...
(TWO W...)
CALL: ...
AGE: 3...

Leonard Castrianno
MISSING

SAMUEL Fi...
Father of a beautiful chil...

ANY INFORMATION ON OSA...
LAST HEADQUARTERS WAS ON
8TH FLOOR OF THE WORLD TRAC...
CALL (800) ... AND/OR

*****MISSING*****

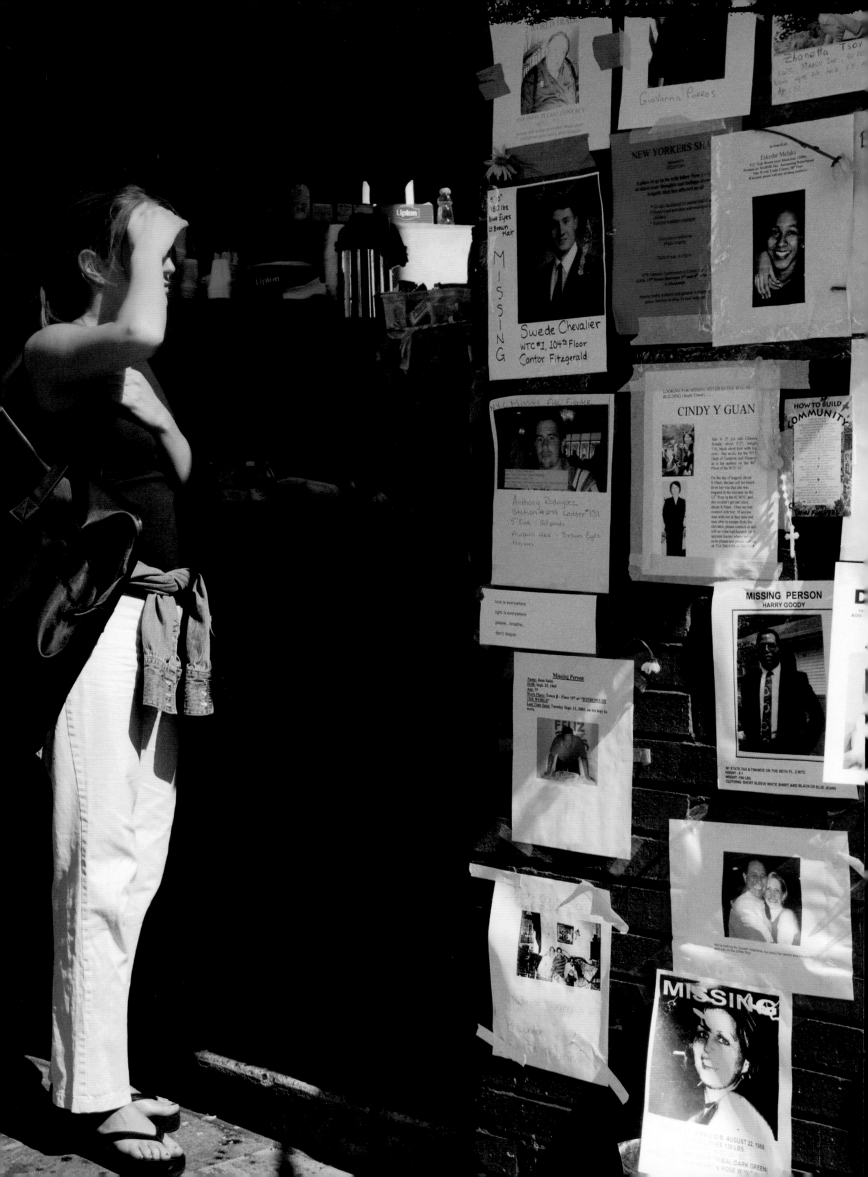

We were to have moved through life together

in all our generations . . .

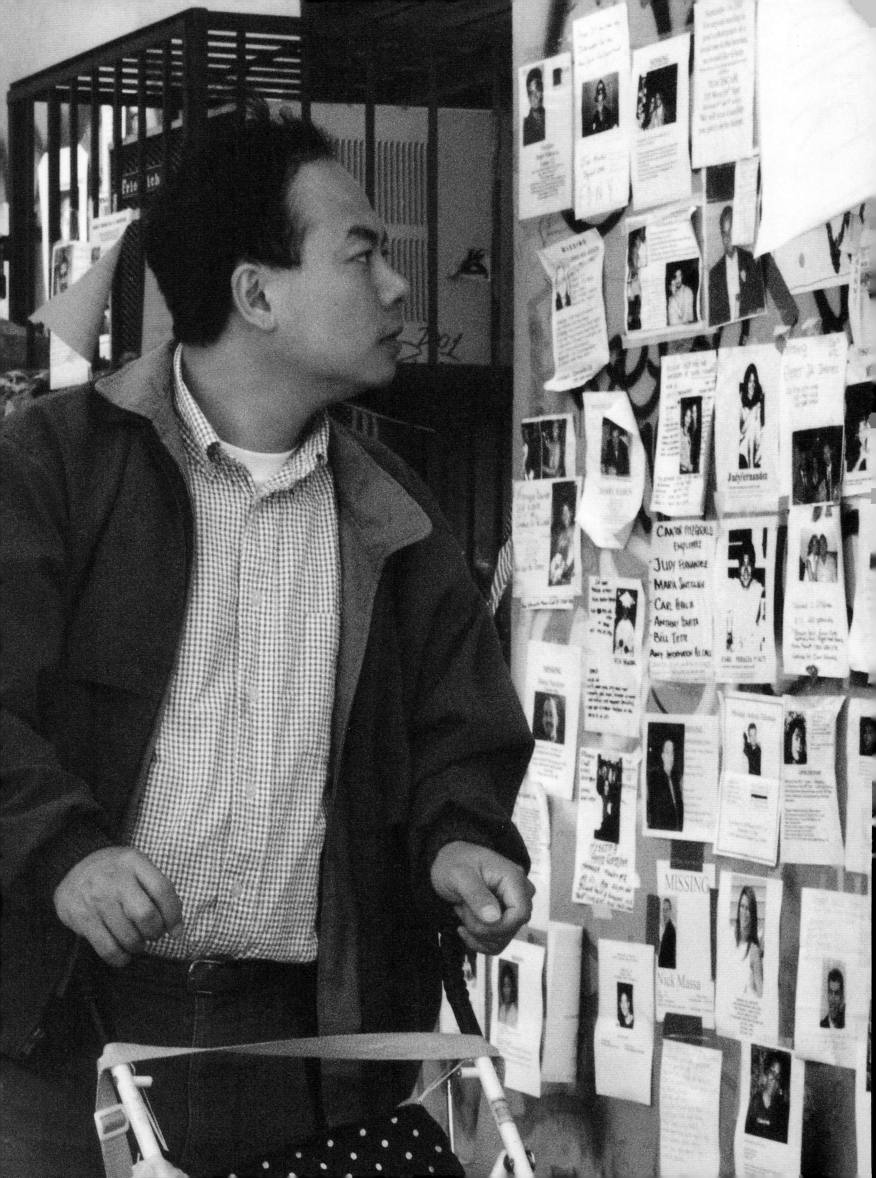

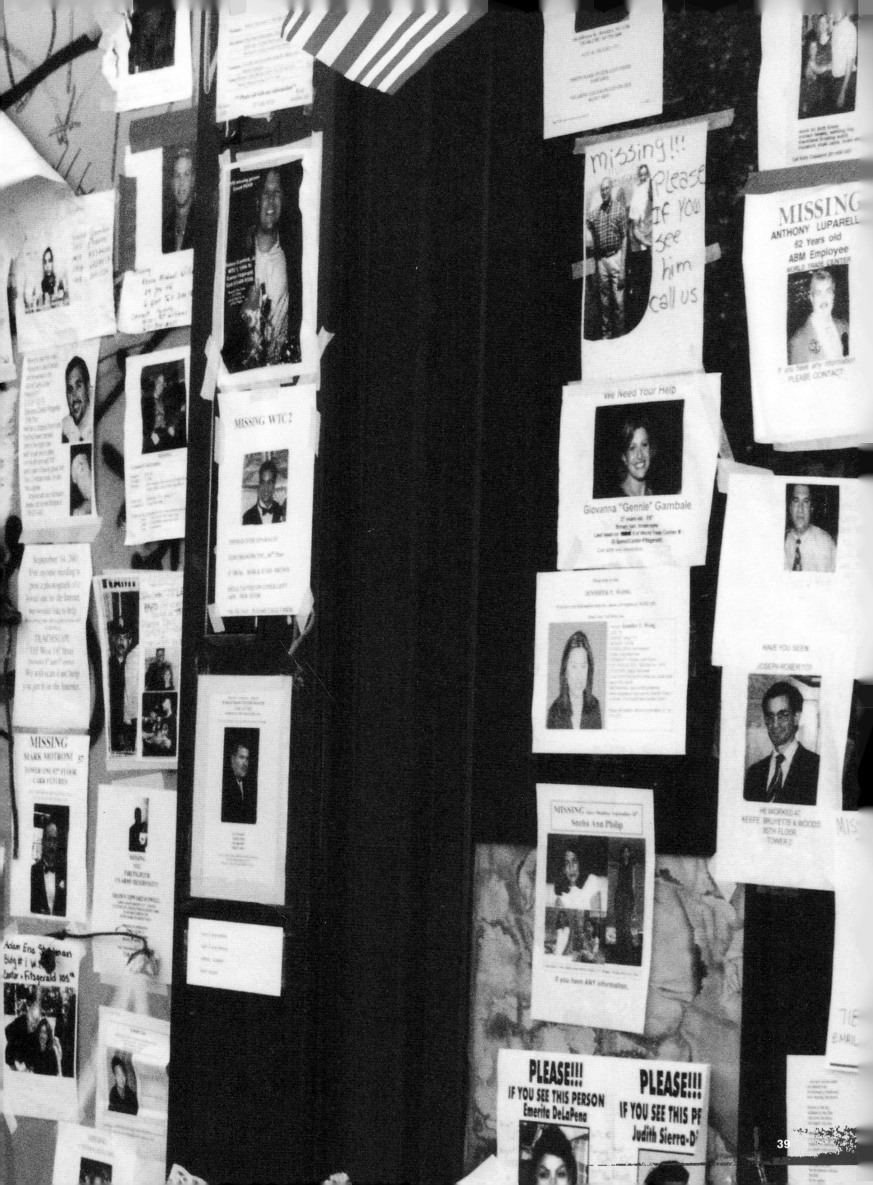

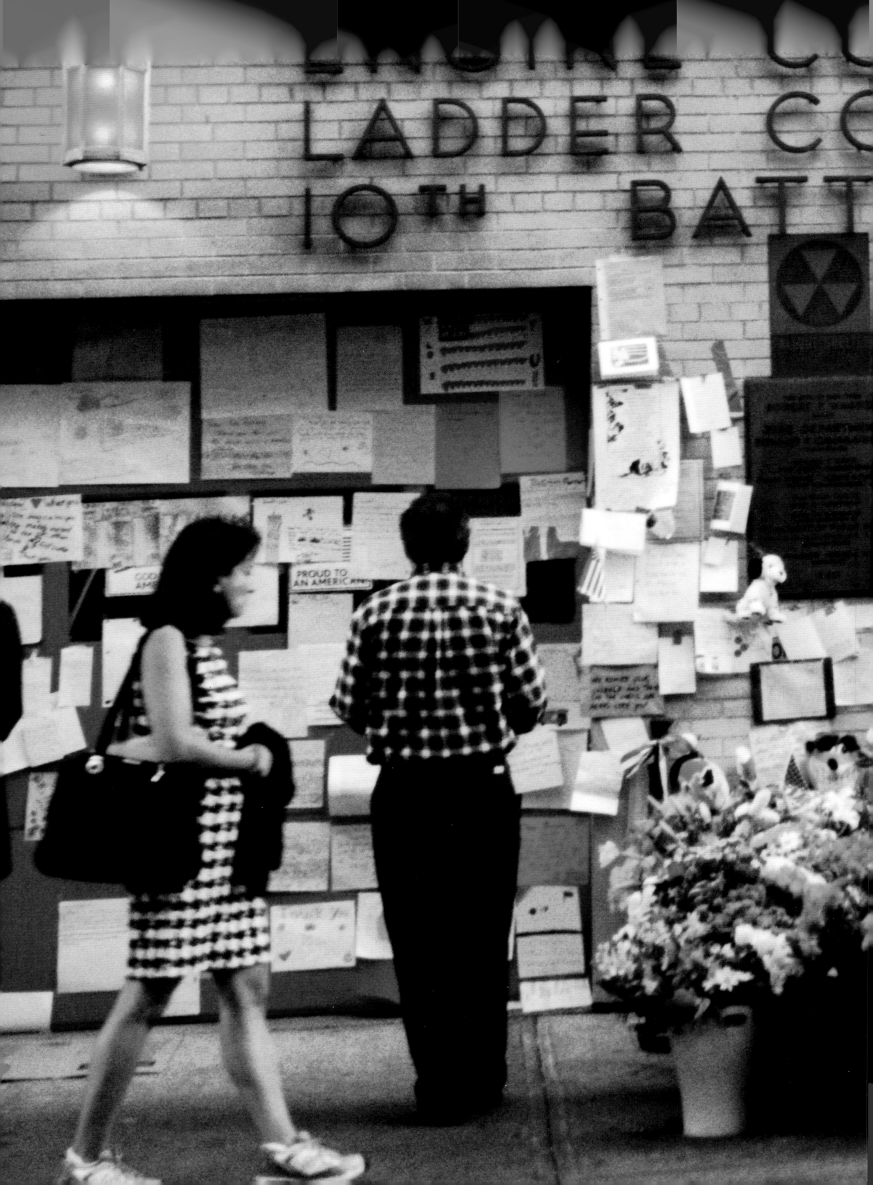

We naturally understood one another though we had never met . . .

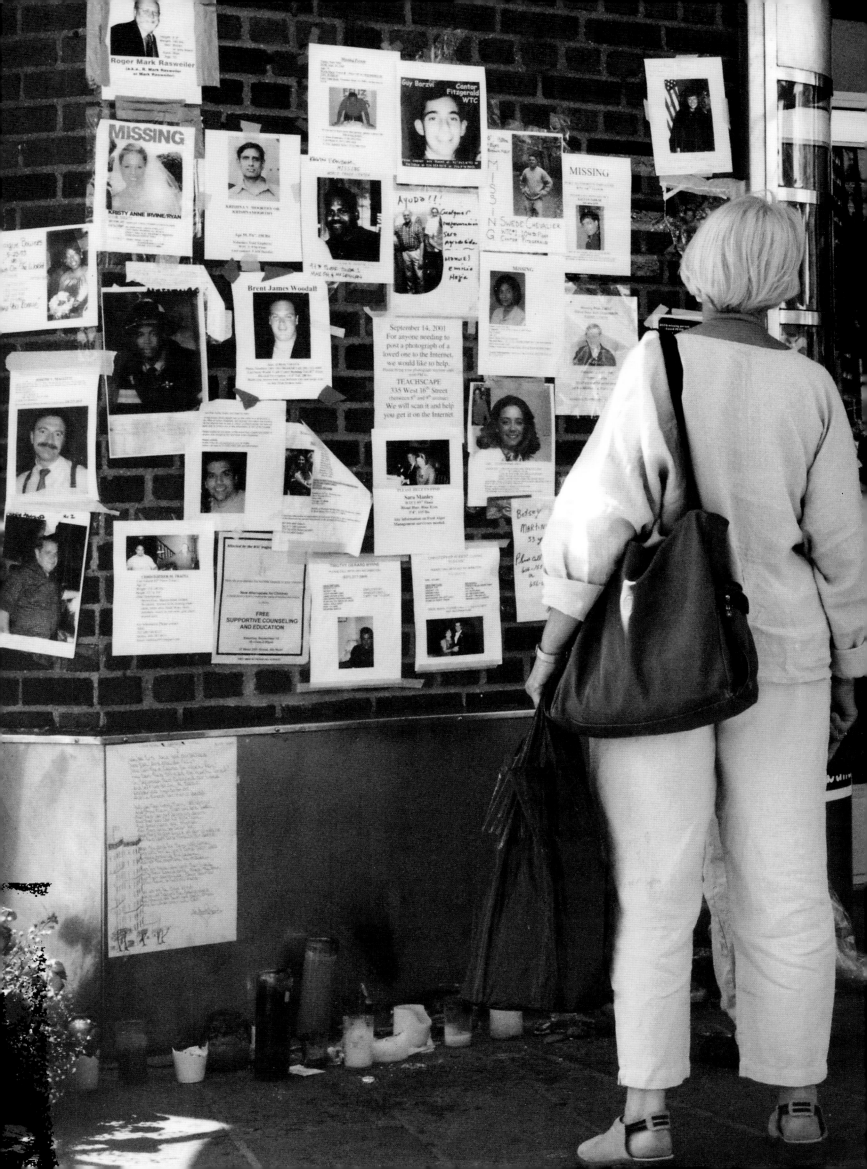

VOICE
OF FREEDOM
WILL NOT
SILENCED!

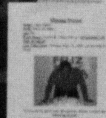

Missing:

Scott Vasel
- 97th Floor
1-666-4978

MISSING
DIANE LIPARI

CASEY CHO

HELP!

LILLY

I would have been comfortable having coffee or a drink with any one of them.

HAVE YOU SEEN
MY DADDY?
JASON JACOBS
PLEASE CALL

The rhythms of their speech were my rhythms,
the figures of speech, the attitudes, the postures, the moods,
were my rhythms and phrases, my attitudes and postures and moods.
It would have been in our natures, under the right circumstances,
to call one another by our first names and to speak of where we
grew up and what we did for a living . . .

MISSING!!!

Joseph A. Eacobacci

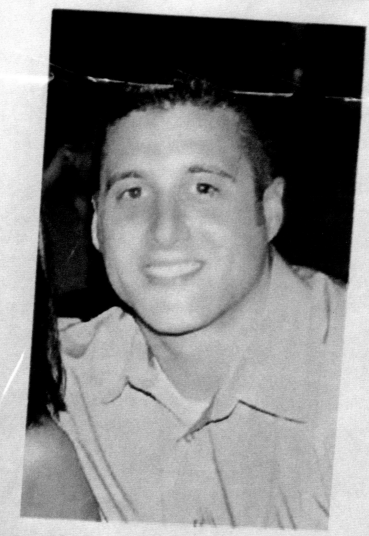

Age: 26 years old
Company: Cantor Fitzgerald, 105th Floor,
1 WORLD TRADE CENTER
Hair: Brown
Eyes: Brown
Weight: 210 lbs.
Height: 6' 0"

LOCAL #608

PATRICK WOODS

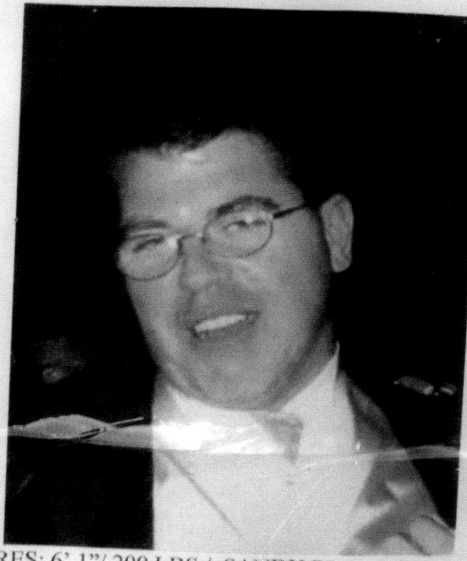

36 YRS. old

FEATURES: 6' 1"/ 200 LBS / SANDY BLOND HAIR / BLUE
EYES... DENTAL WORK DONE ON FRONT TEETH...HAS A 2
INCH SCARE ON EACH RIB CAGE FROM SURGERY

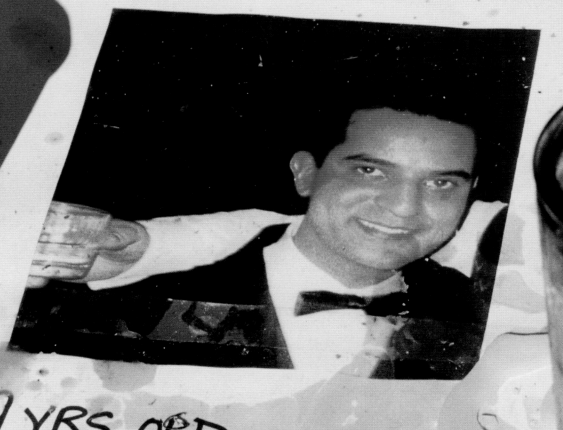

TAIMOUR KHAN

2.9 YRS. OLD
5"10' - 150 PDS.
DK. BROWN HAIR - LEAN E
WORLD TRADE - 92ND FL.
RR FUTURES

HELP FIND

We would have made our private judgments of one another,
we might have pointed out our differences in age, in education,
in background, but we were of the same cloth,
we were one another's context, . . .

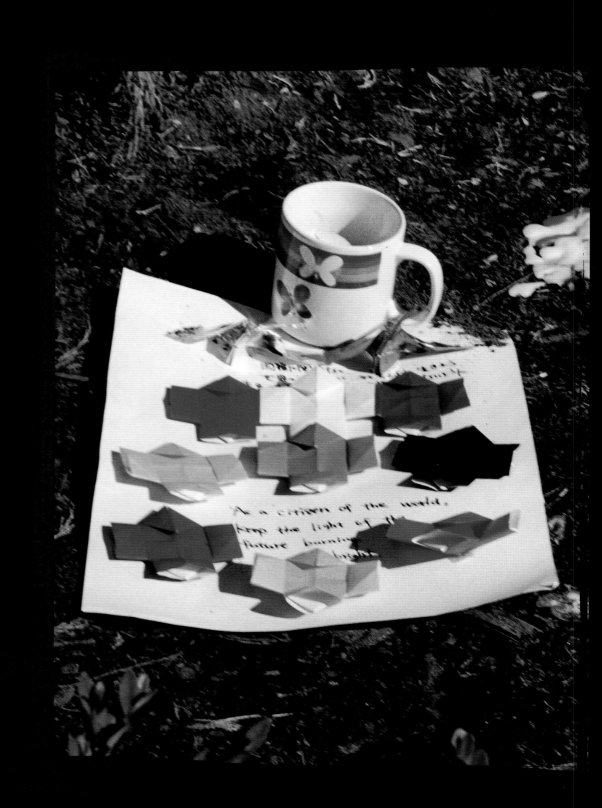

. . . in our numbers we provided

the urgent life of the city for each one of us.

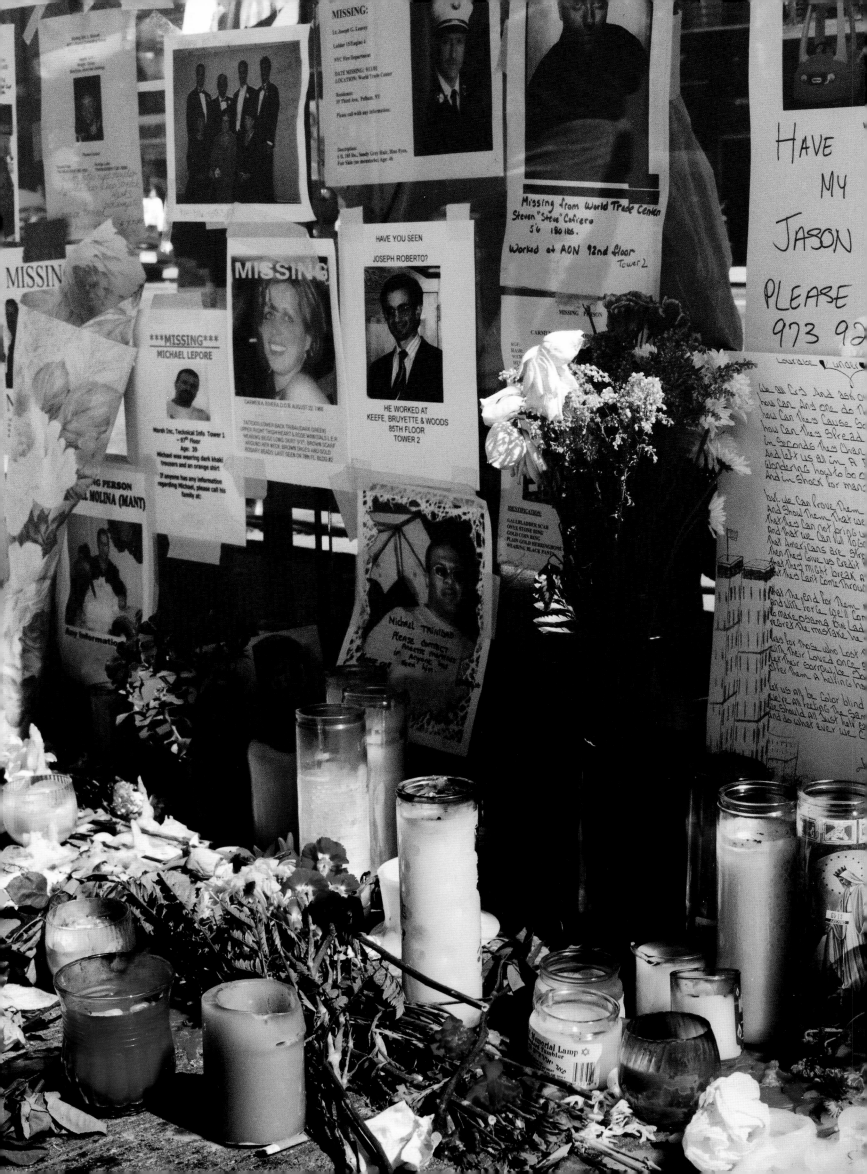

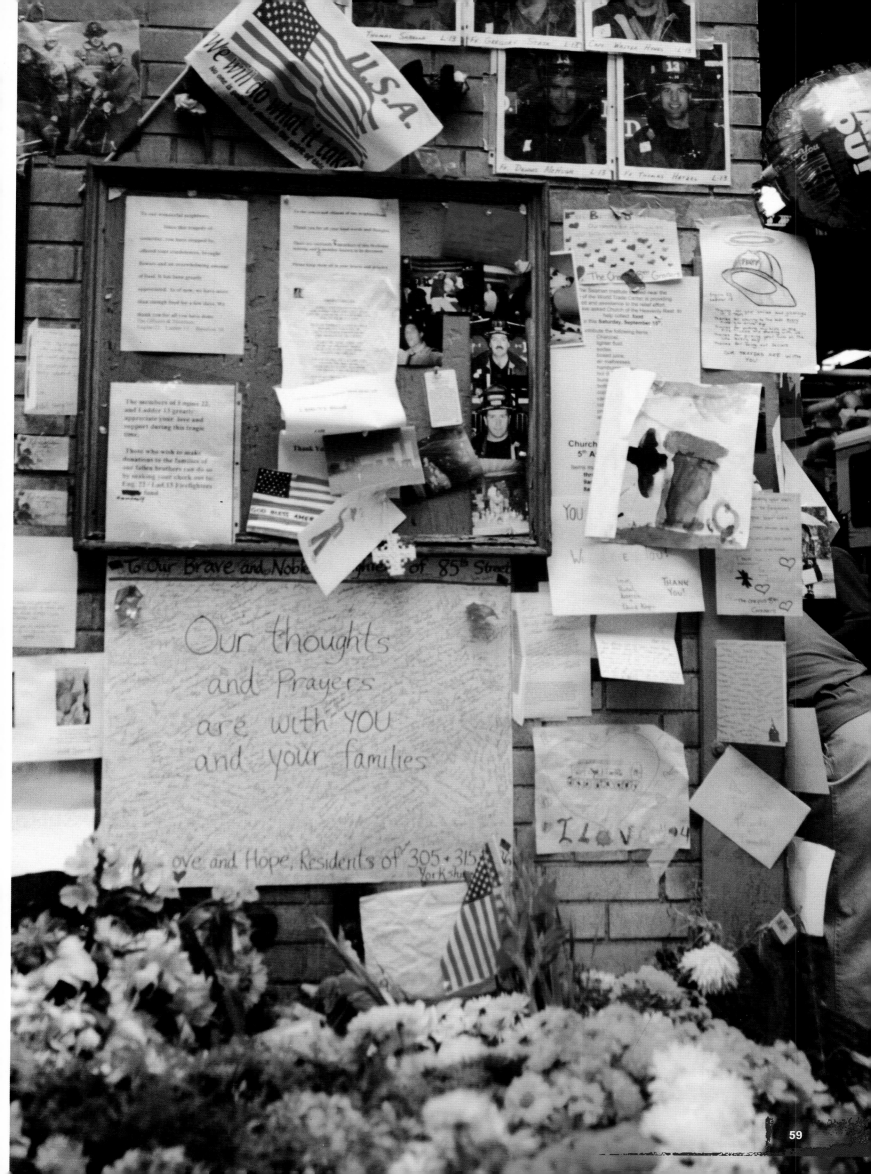

59

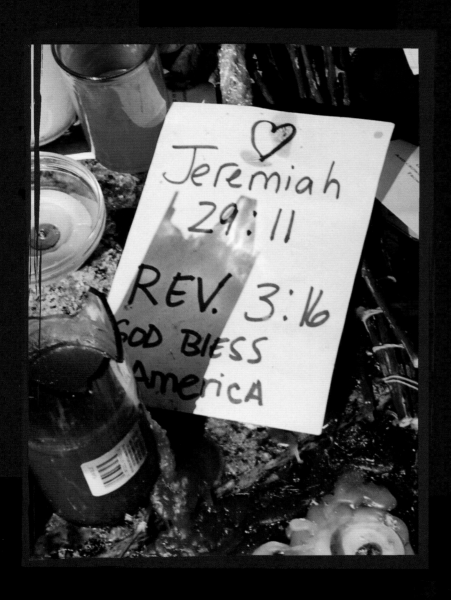

As strangers, we had an understanding.

We would appear on the perimeters of one another's consciousness,

in one another's sightlines, on any given day, passing in the street, riding

the subway, shopping for our families, going to the ballgame, waiting on

the same street corners for the light to change, heading home to the joy of

our children, taking the same holidays, affirming our lineage by the births,

graduations, weddings and funerals of our families, all of us doing the

same things in our different ways, mirroring one another's daily lives as

we flowed through the streets or rode under them, always intent on our

business within the dimensions of our city.

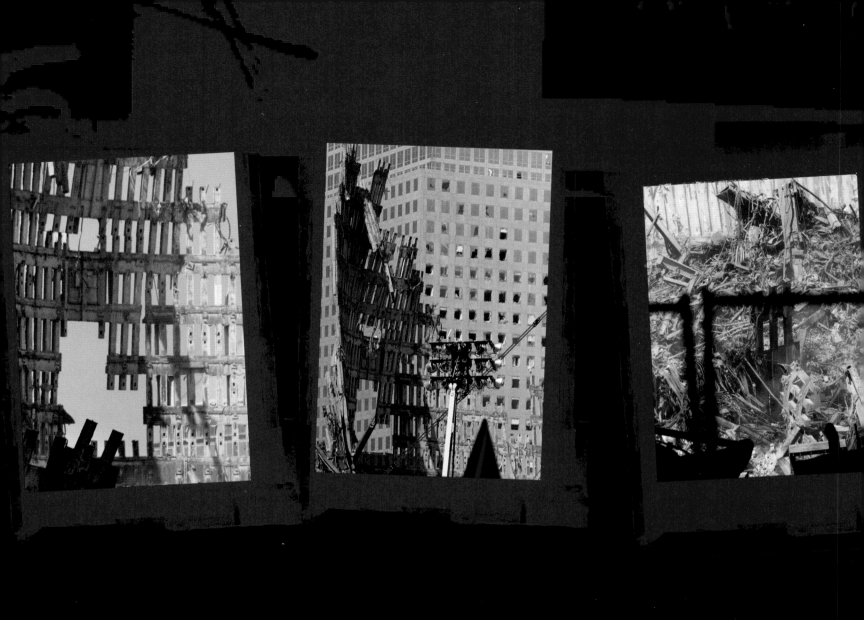

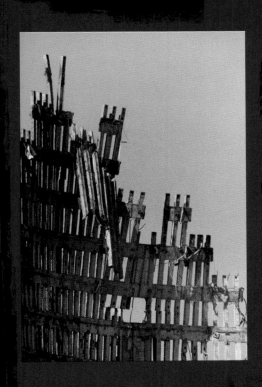
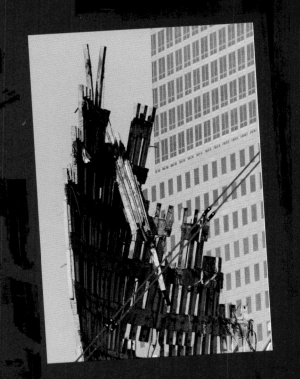
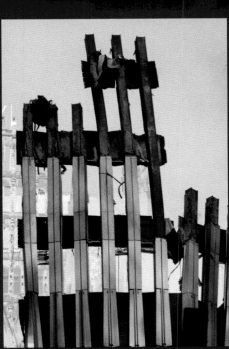

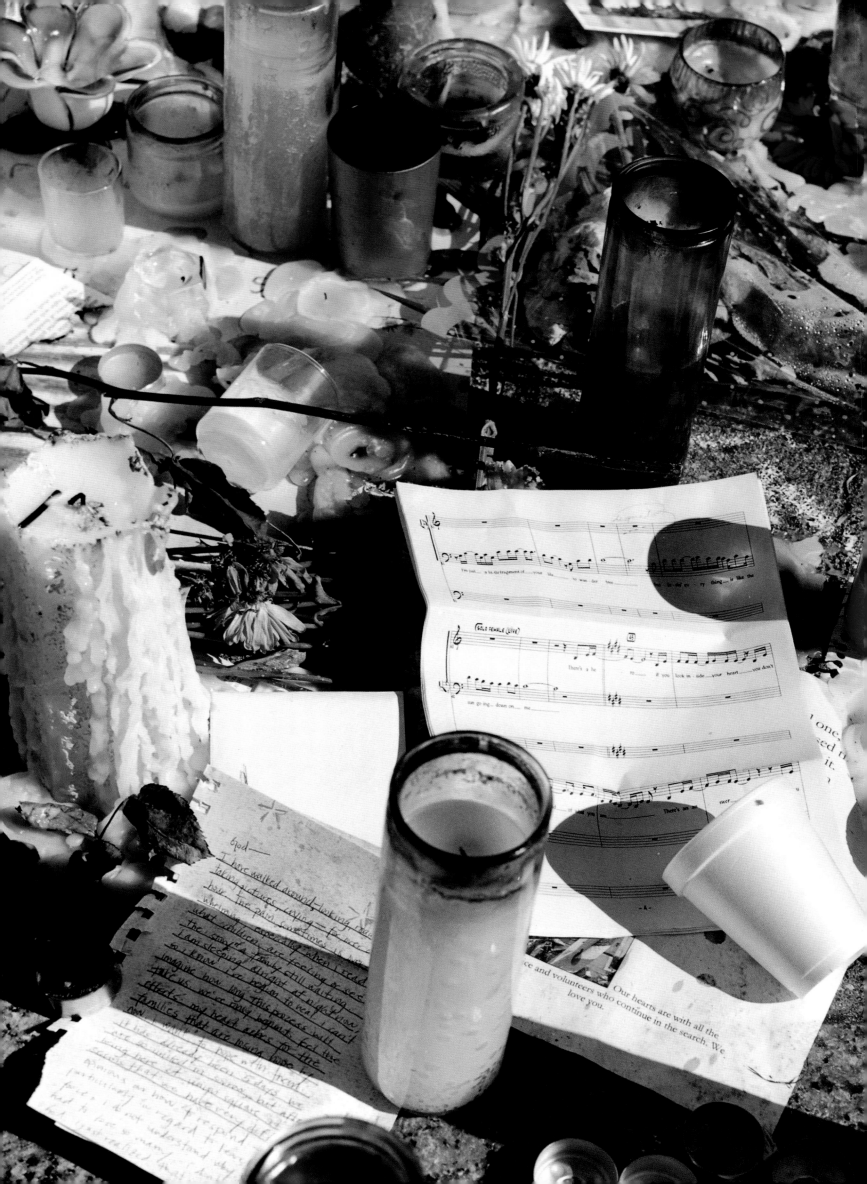

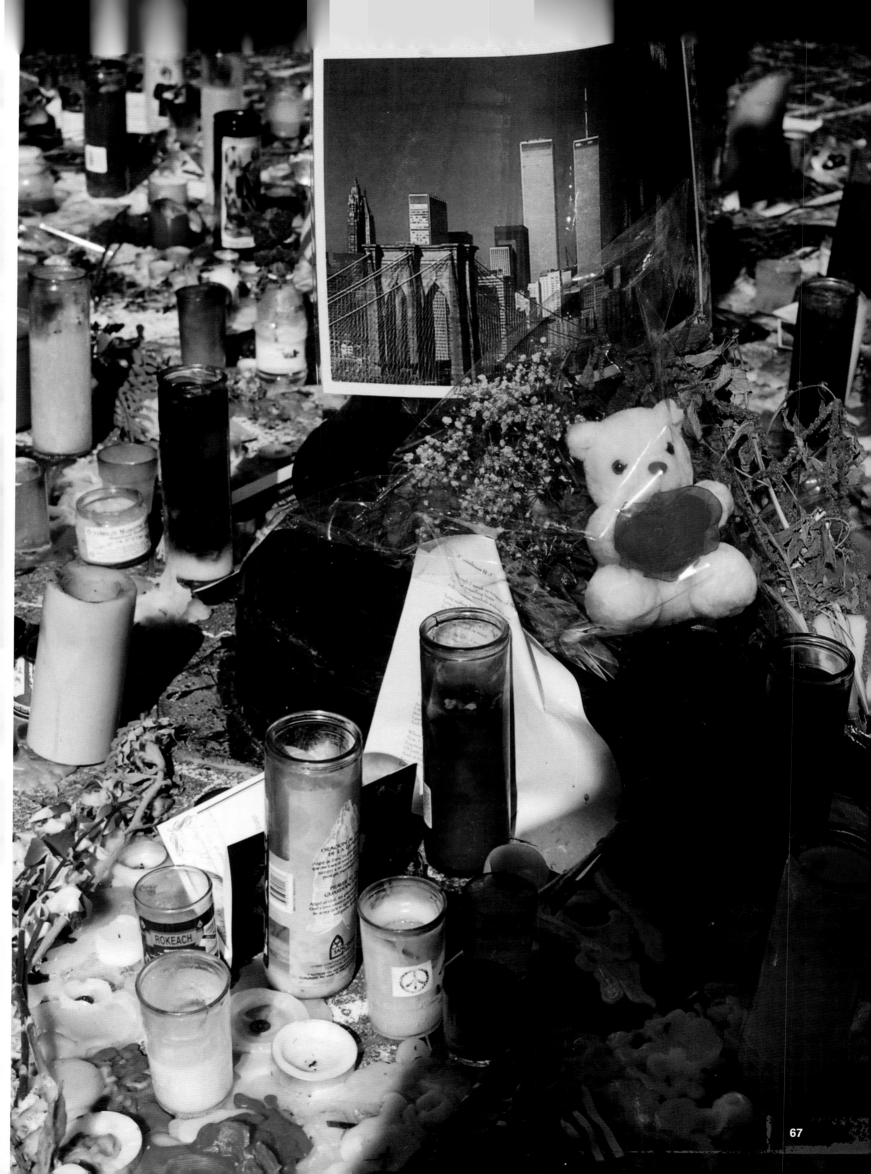

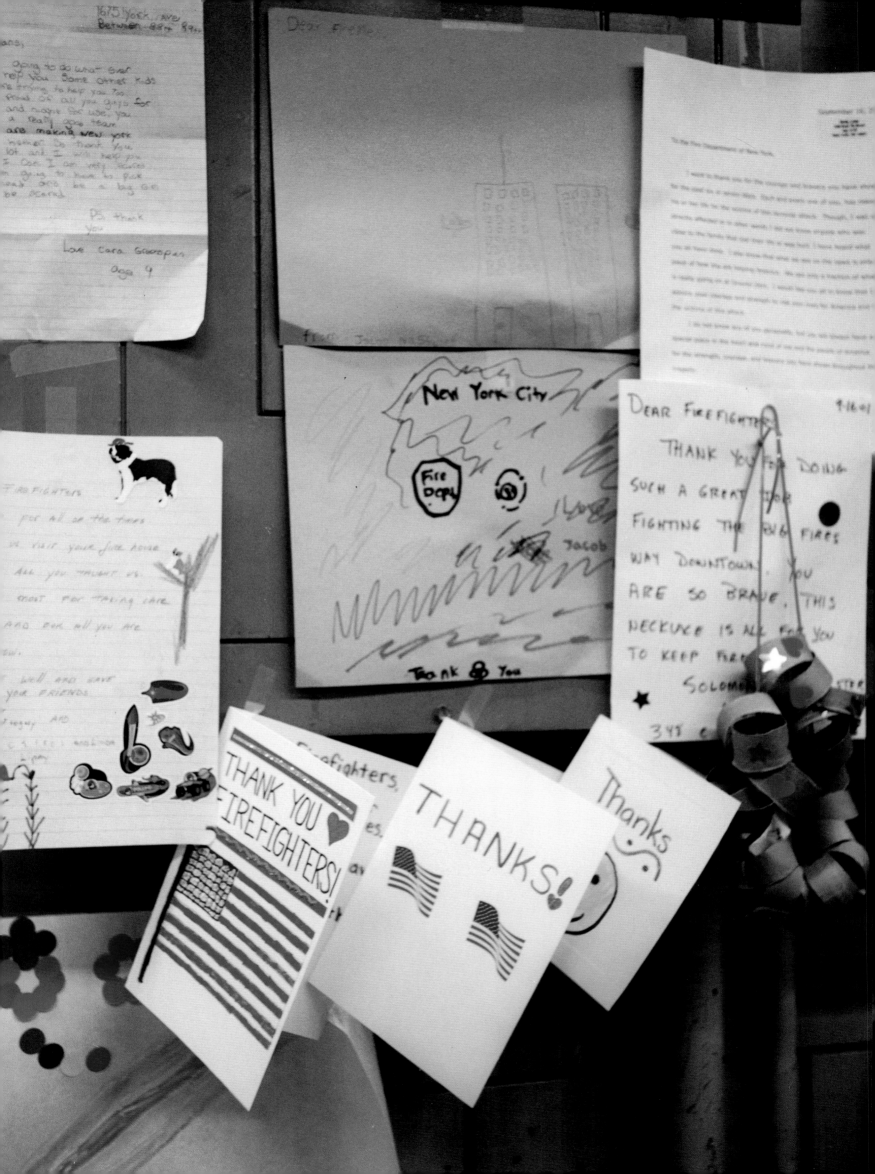

We were joined too by the belief that underneath all our flaws
and weaknesses and angers and stupidities, was a bedrock human
decency, and that despite any lack of consideration we may
have shown one another there was always the possibility, through
our acts of atonement, self-recognition and mercy, of reforming,
of finding redemption on any given day to the day of our death.

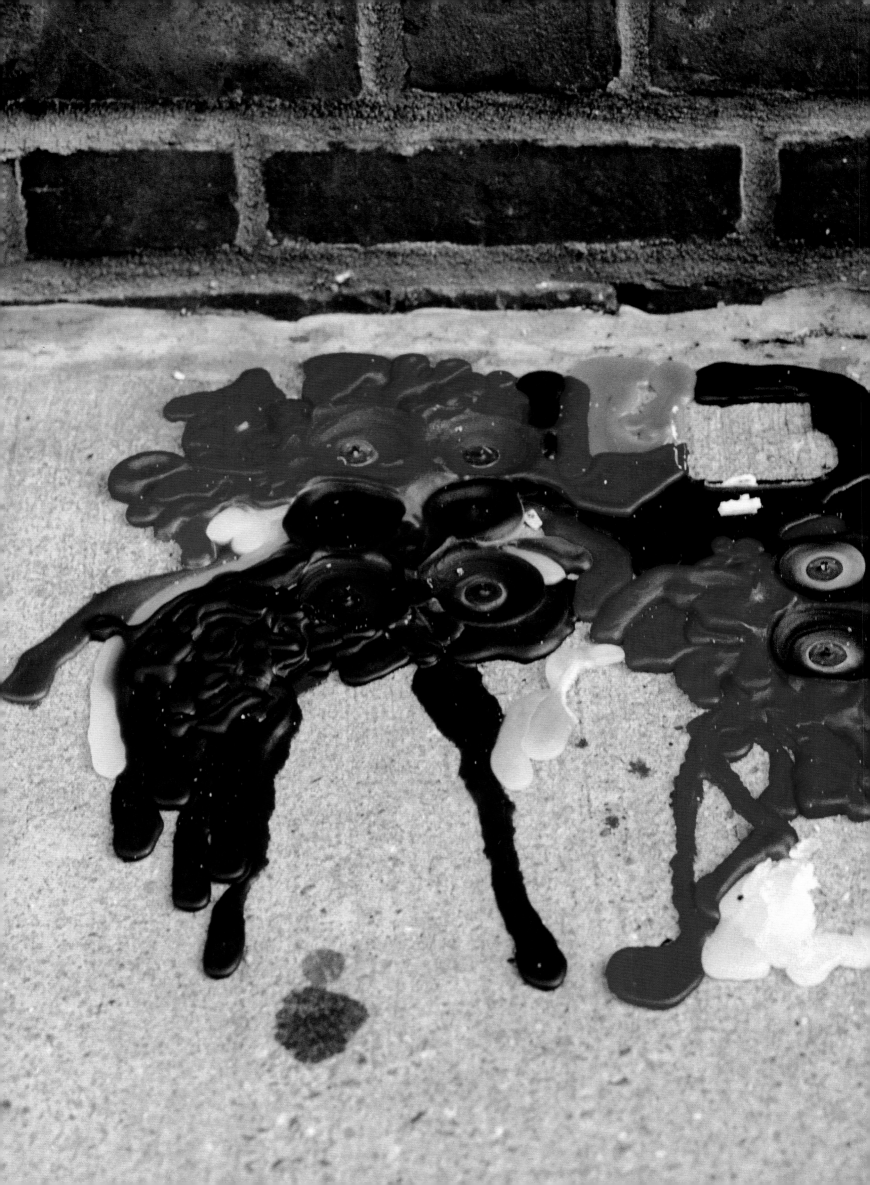

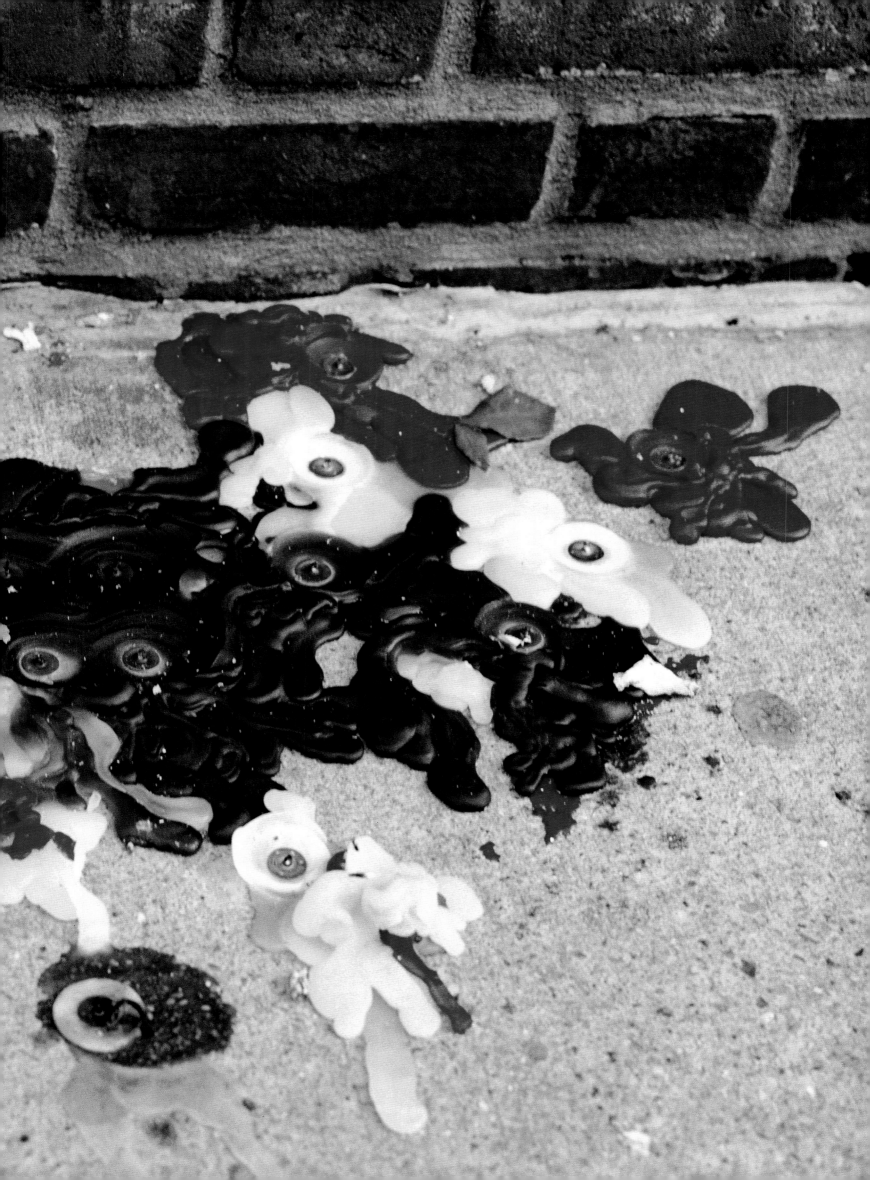

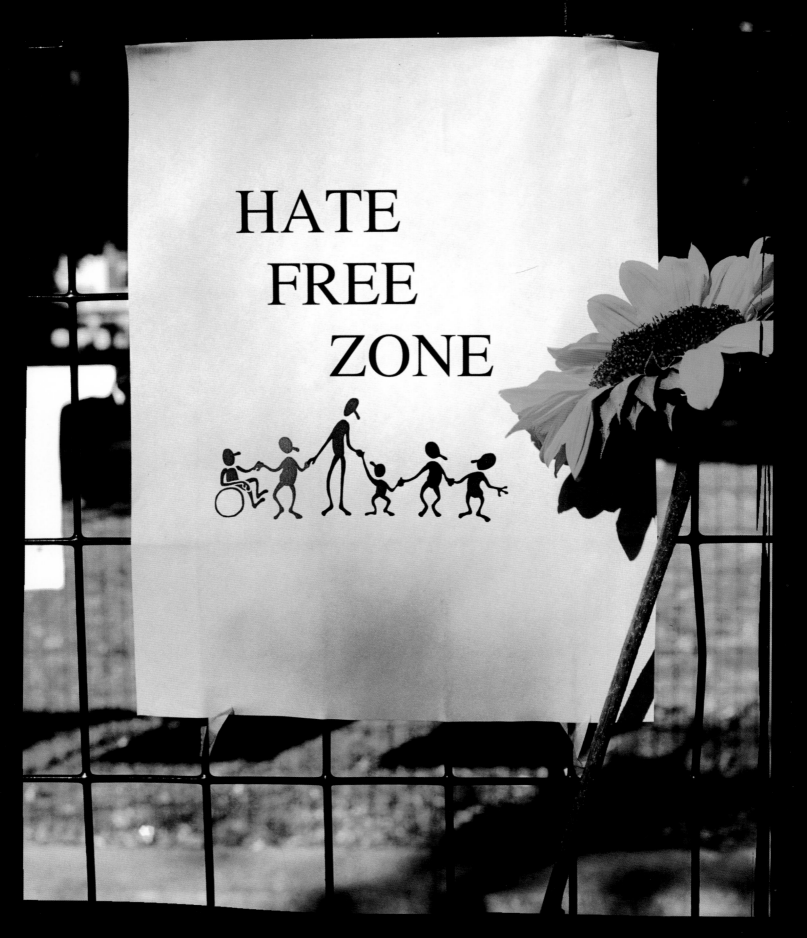

In our unspoken fervent love of the freedom that grants to each of us the ultimate command of our own lives, we knew we were privileged not by our material wealth but by the choice that was ours to live life any one of a thousand ways, to ennoble ourselves or degrade ourselves, to believe or disbelieve — whatever our struggles, and through what convolutions of thought, everything we made of ourselves being up to us, a matter of our private determination under a system of governance that, however imperfect, could not intervene in the life of our souls.

THANK
F.D.N.Y
&
NYPD Bl

You

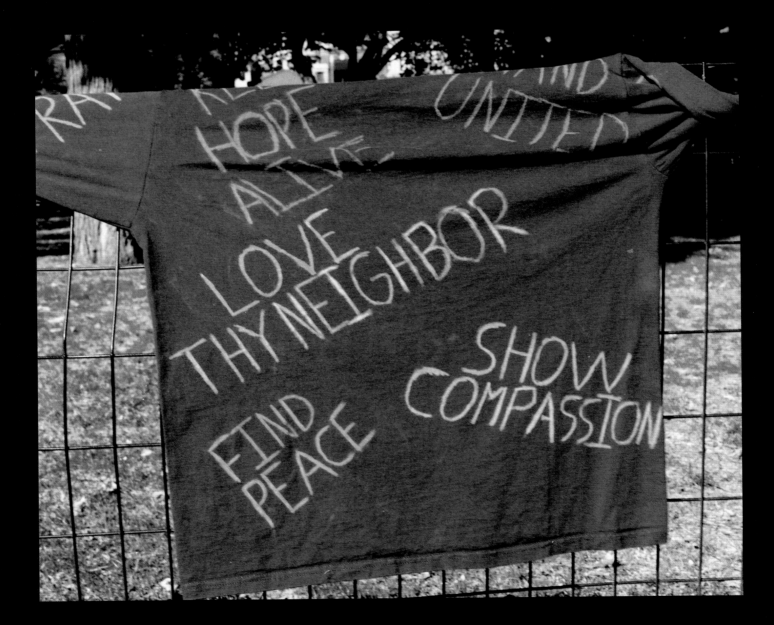

We understood that we may only grudgingly accept our differences

but in this city there are no infidels, no philistines and no eternally damned . . .

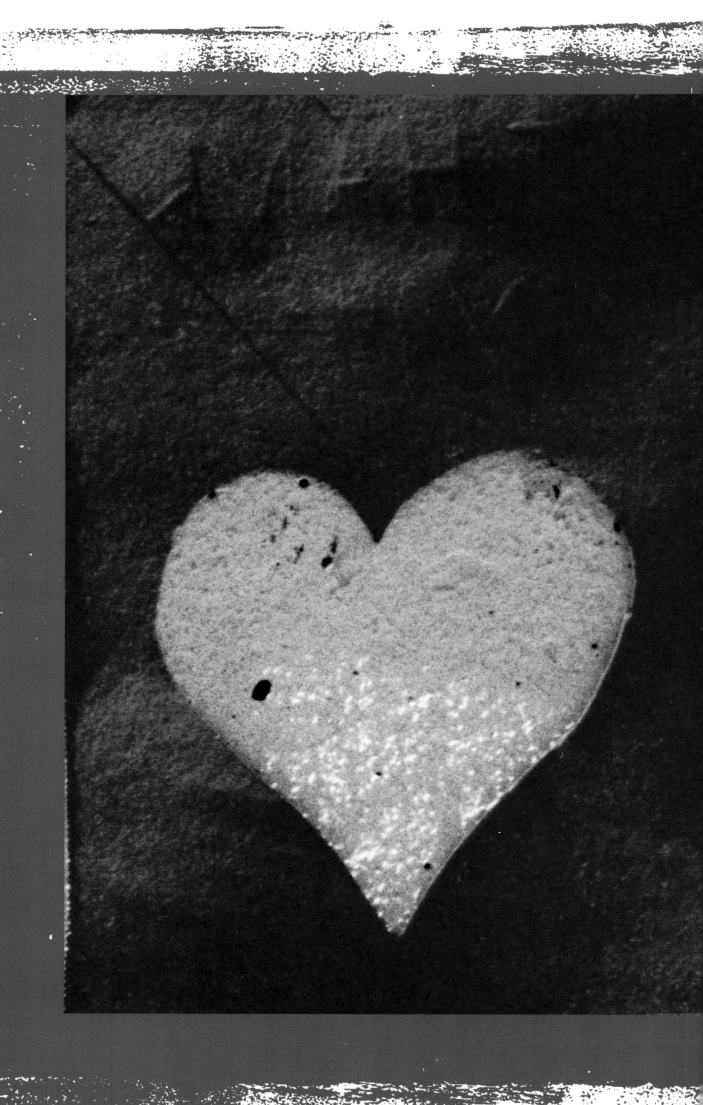

God
Bless
You!

Love
chelse
age 6

NO MORE INNOCENT LIVES LOST

THE PEOPLE OF AFGHANISTAN
ARE NOT TERRORISTS!

TERRORISTS HAVE NO
COUNTRY!

INDISCRIMINATE KILLING
IS NOT THE
ANSWER!

. . . and that none of us is that presumptive to claim so,
 however ardent we are in our observance of what we believe.

Some of us may even have recognized the possibility of God's blessing in the struggles of those who can't quite accept Him. But for all of us our relationship to God is finally a private matter, our own business, no one else's. And that is the way we lived, and will live, in the necessary humility of the secular state.

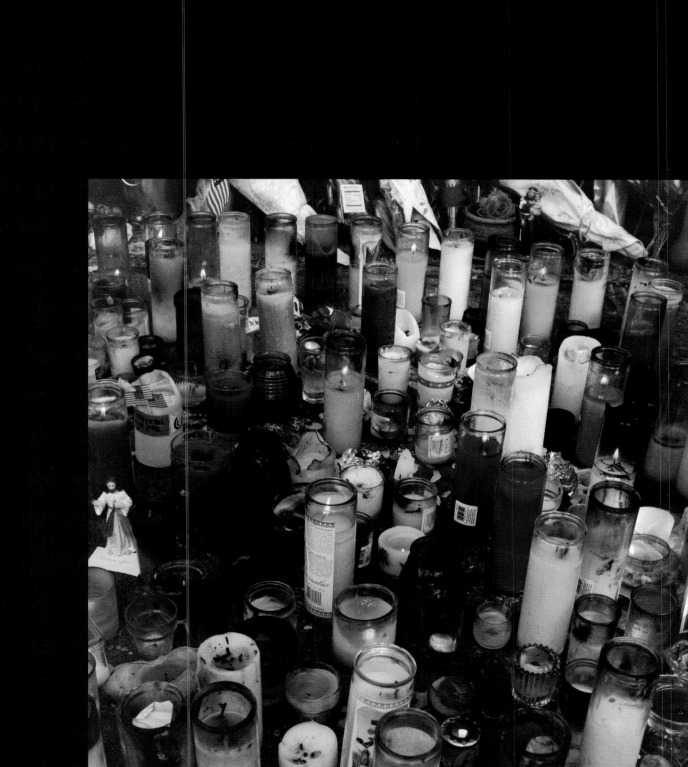

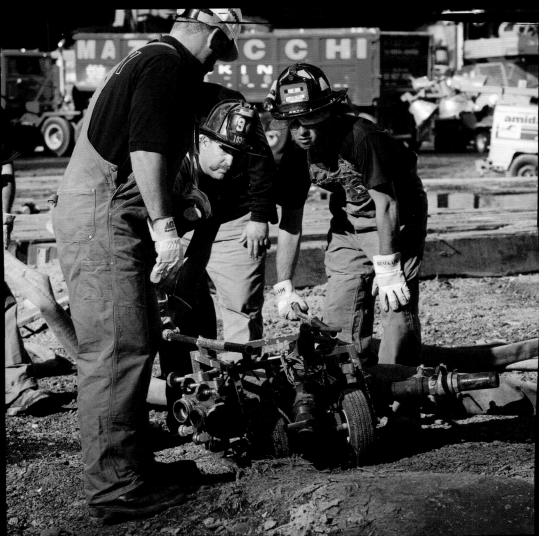

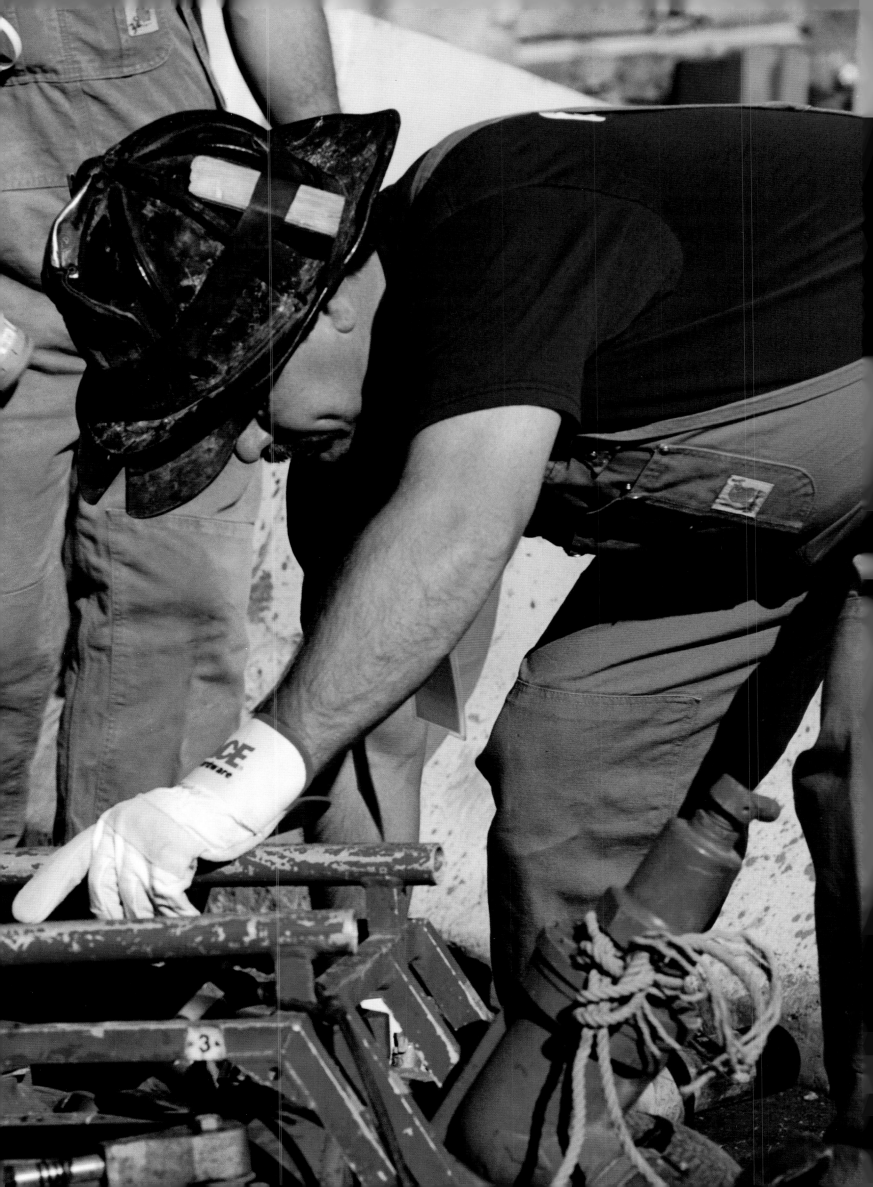

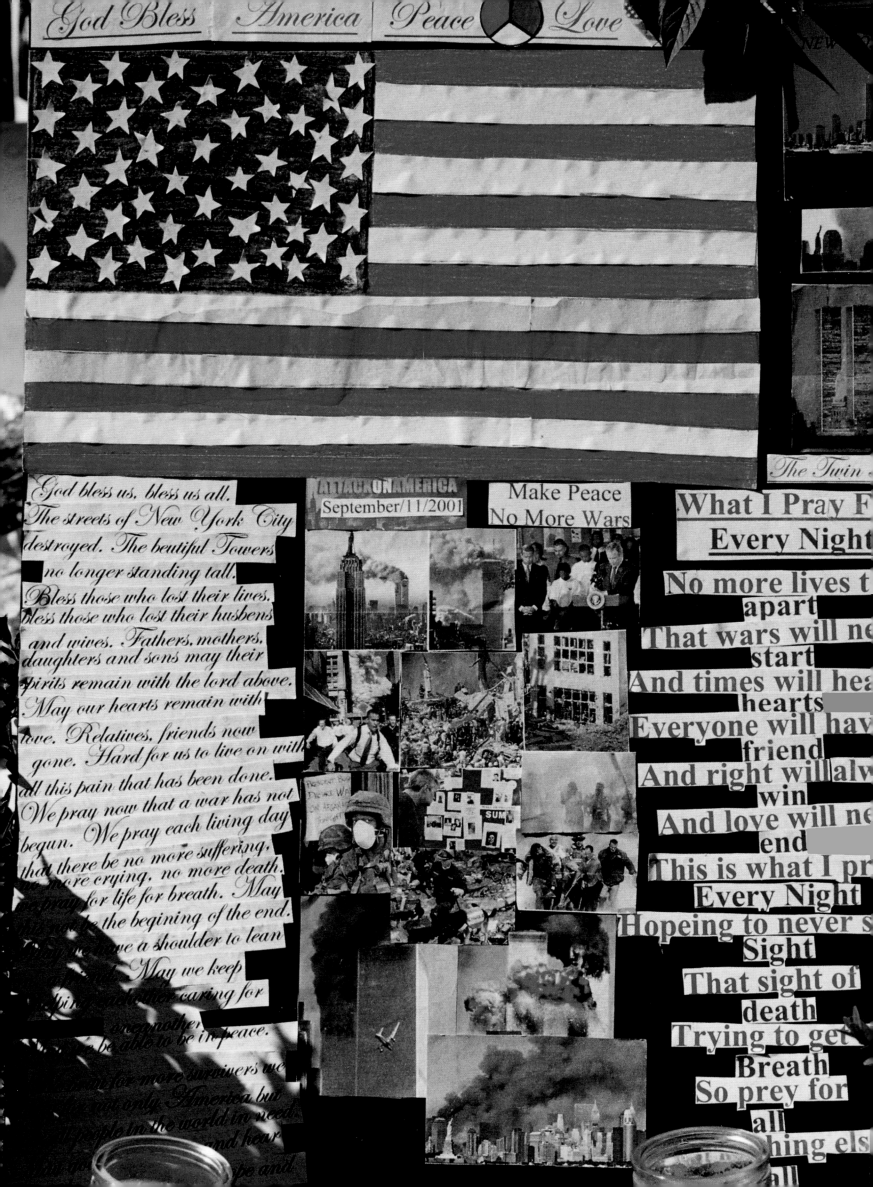

This country and its institutions are a work in progress . . .

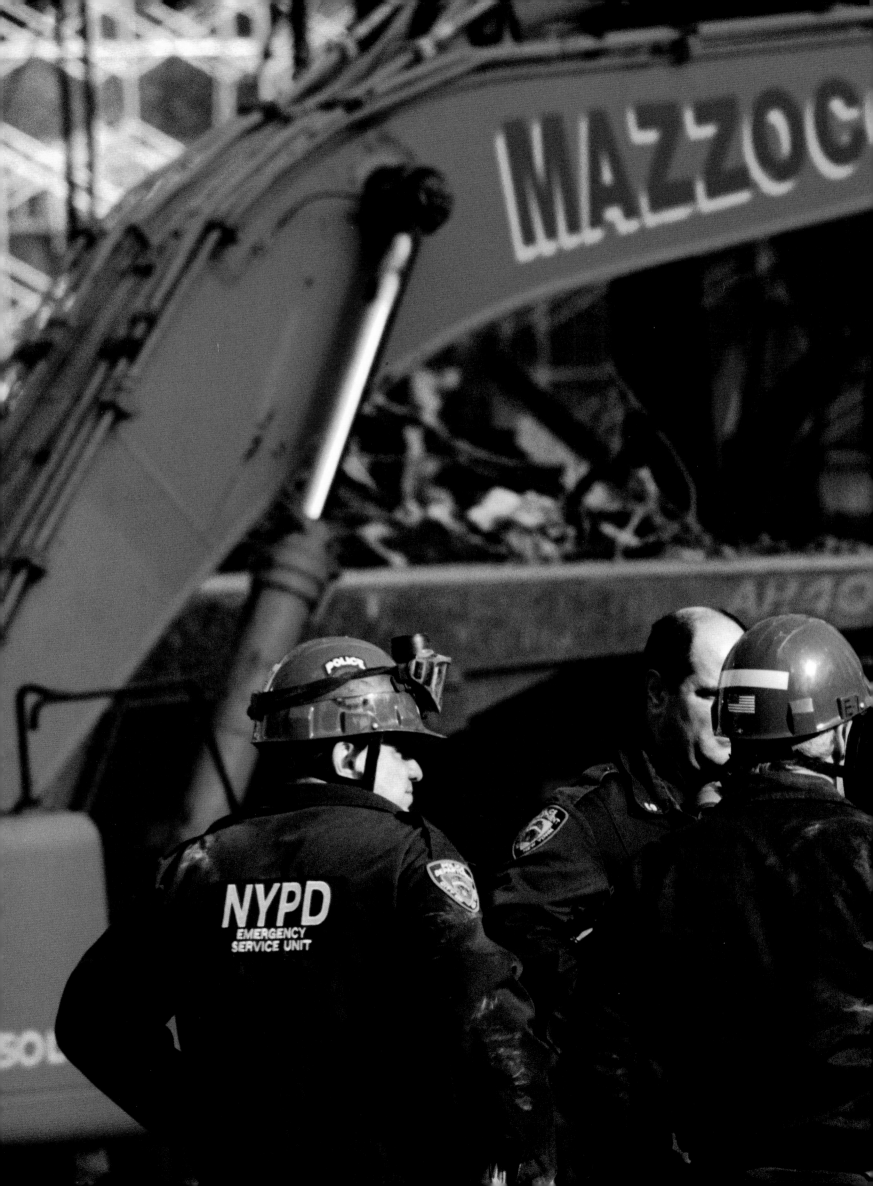

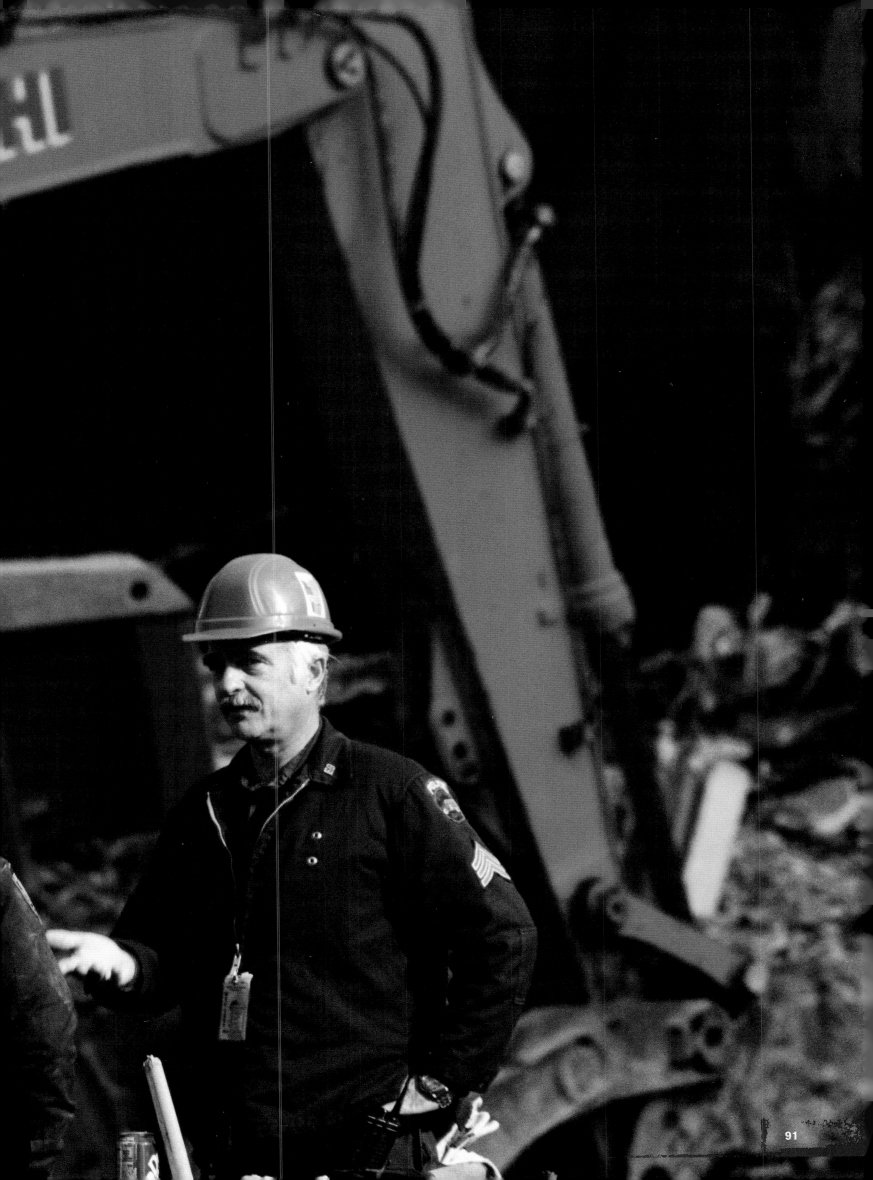

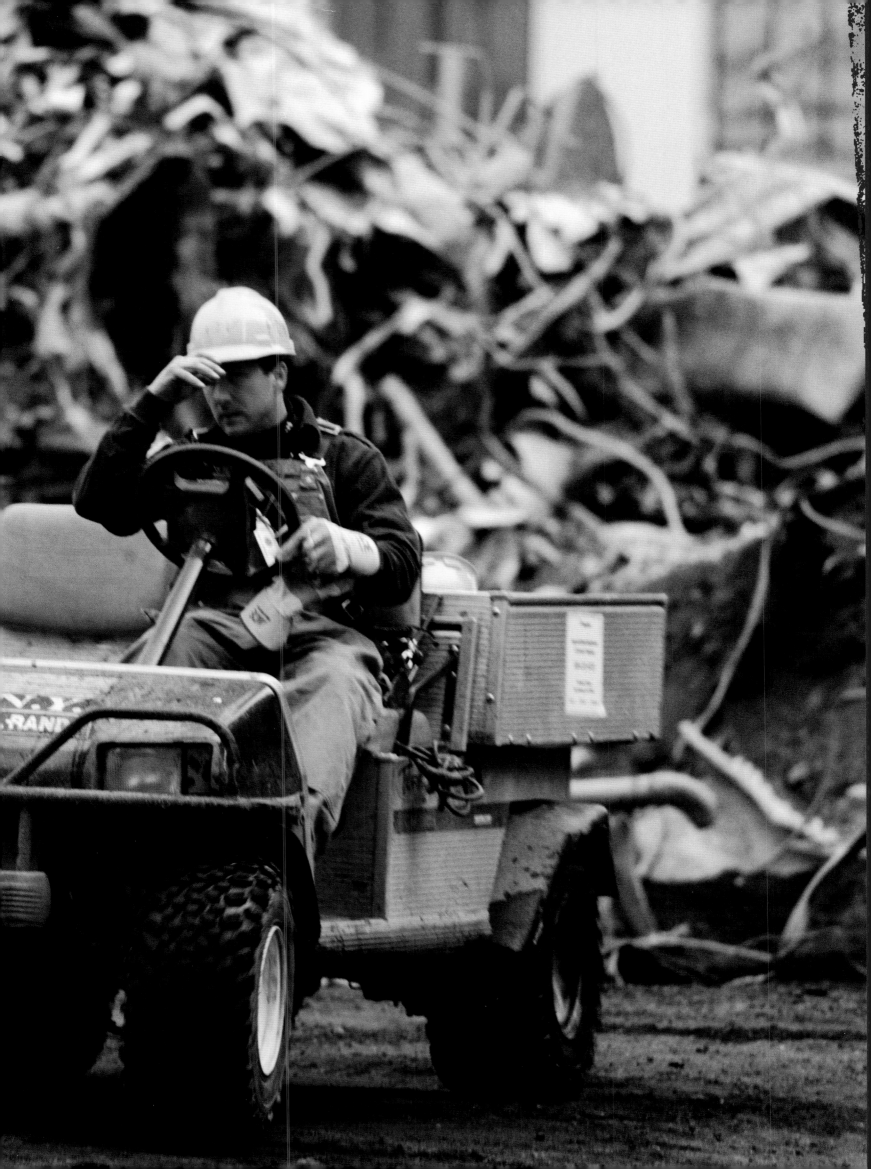

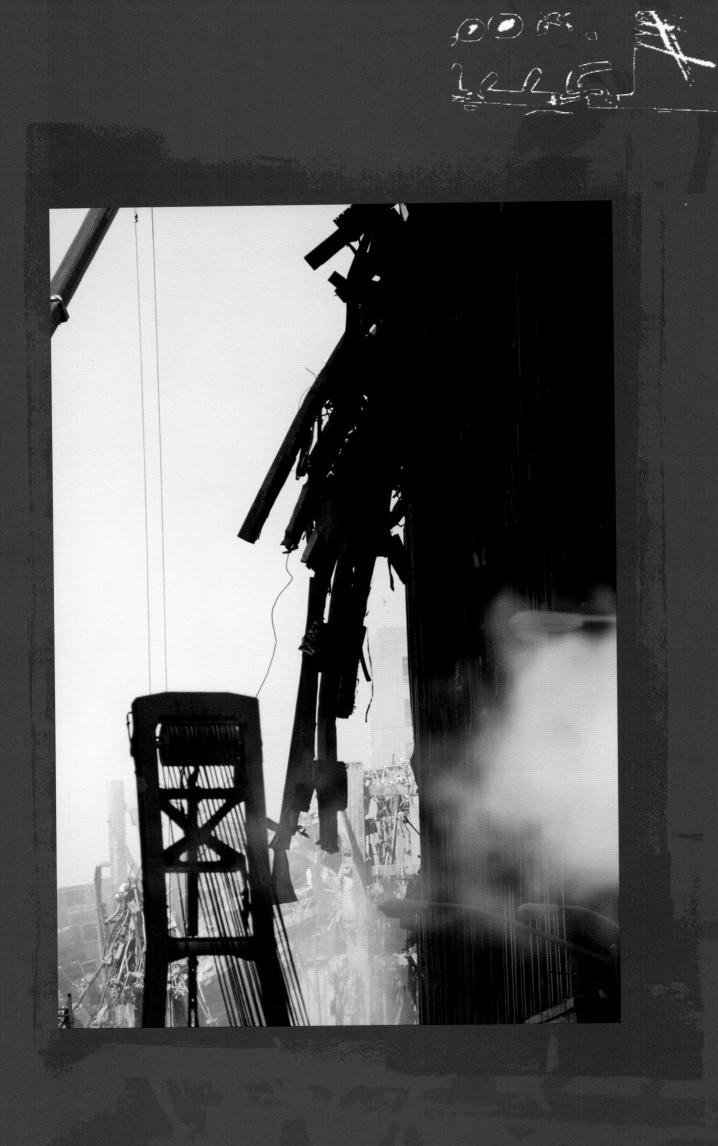

Our story has just begun . . .

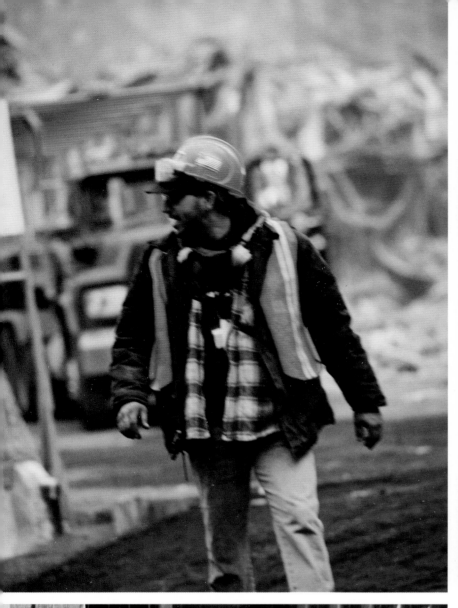

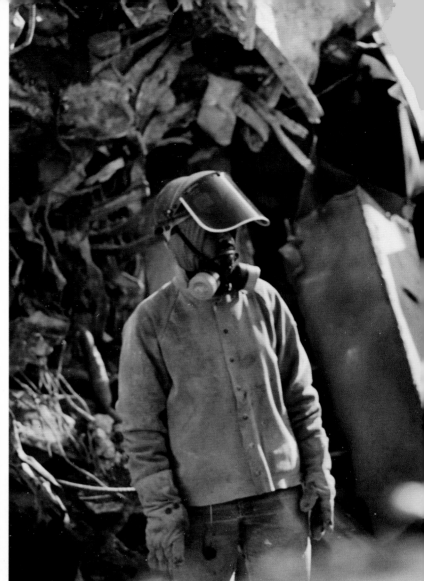

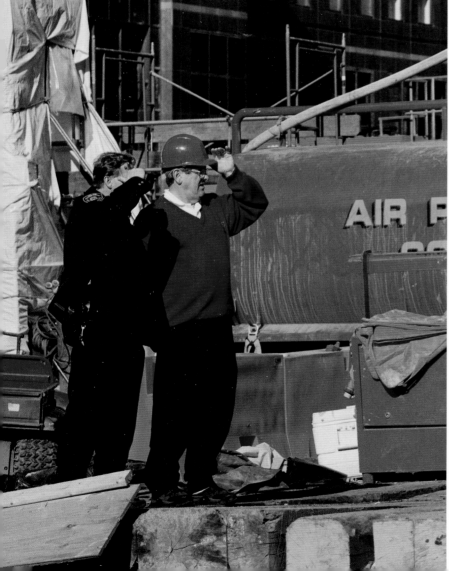

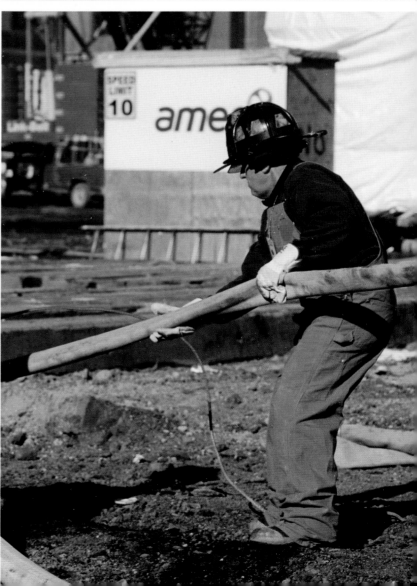

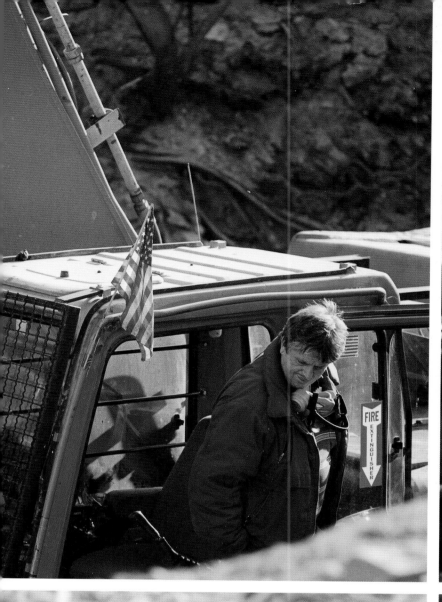
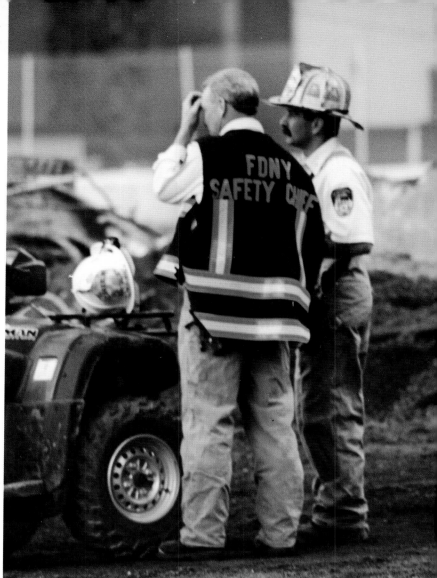
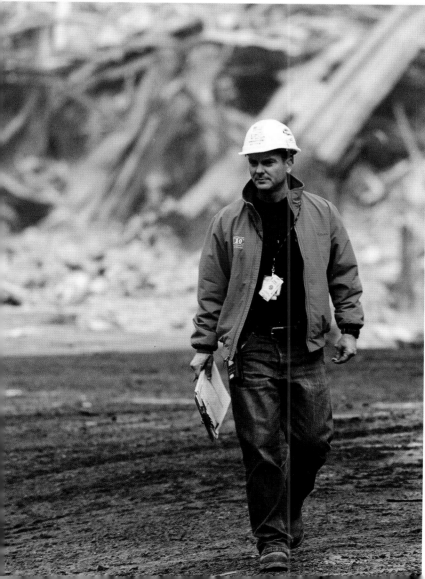
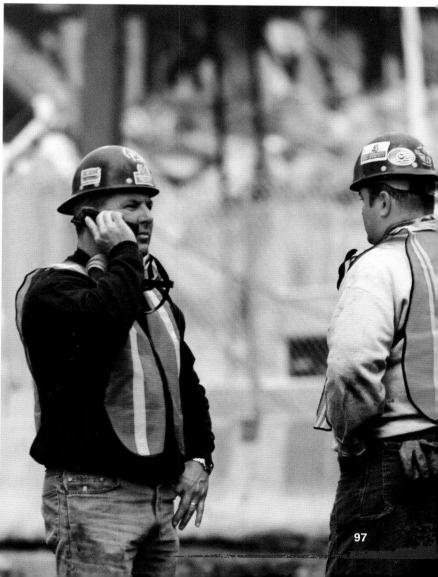

Thank You for all the
wonderful things you are doing
for New York. You are more than
a tremendous help to our country.
I am praying for your safety. God
Bless America And God Bless
You!

Love,
Samantha G.
7 years old

Our raucous and corruptible political system lumbers on
toward a true and universal justice . . .

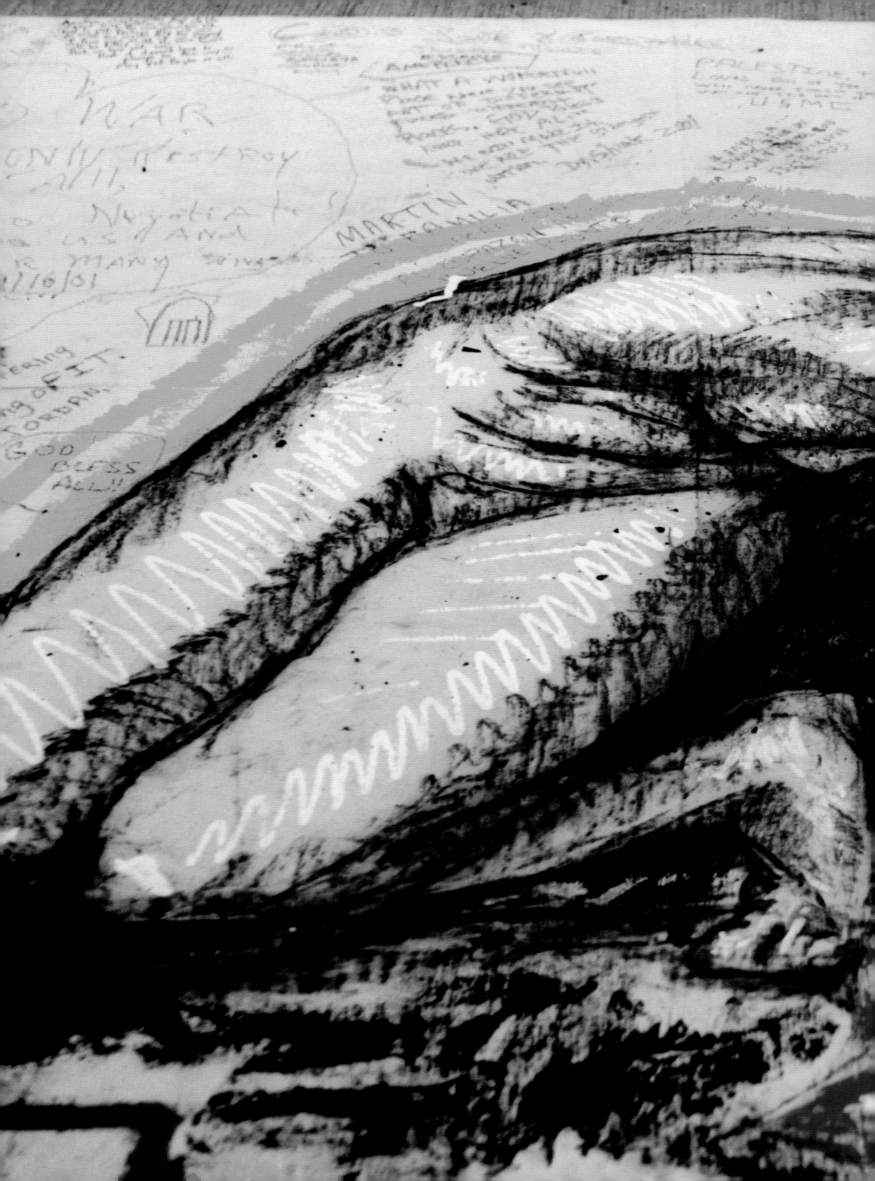

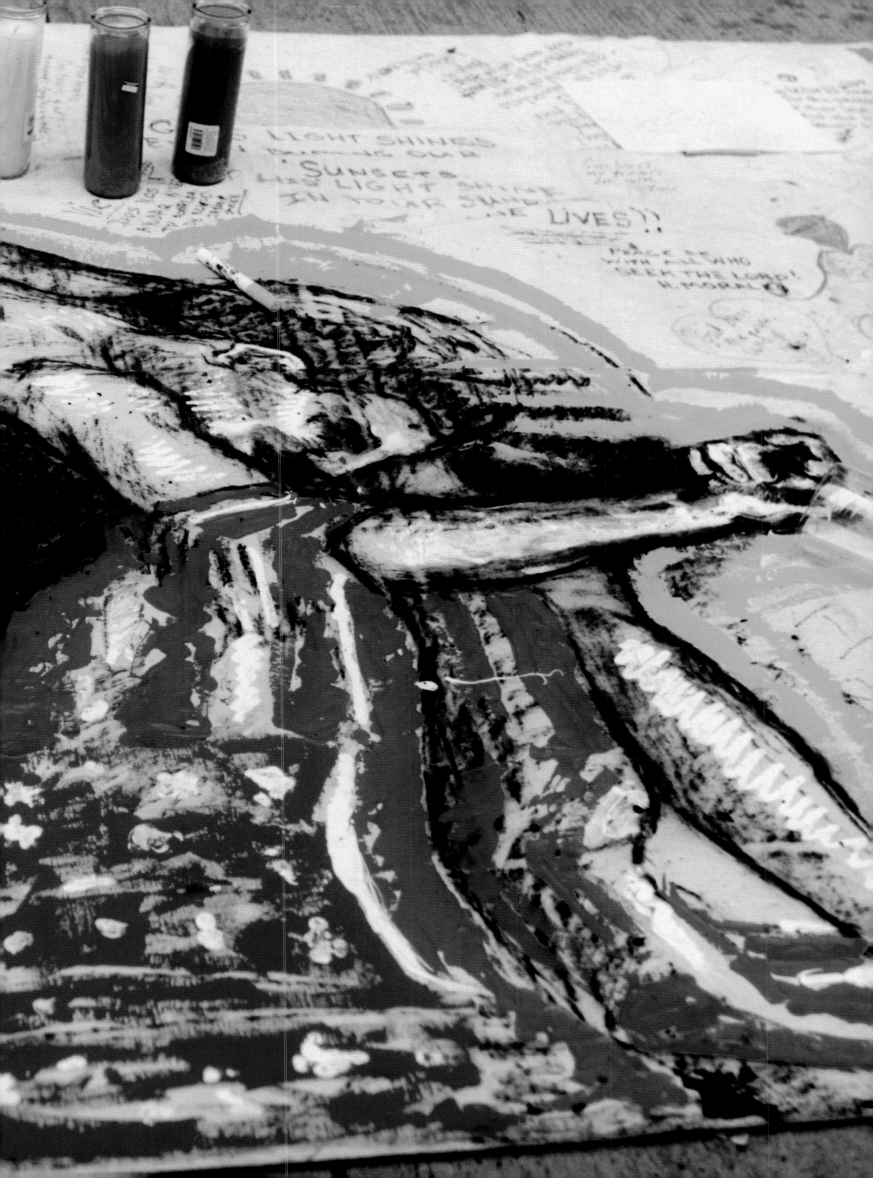

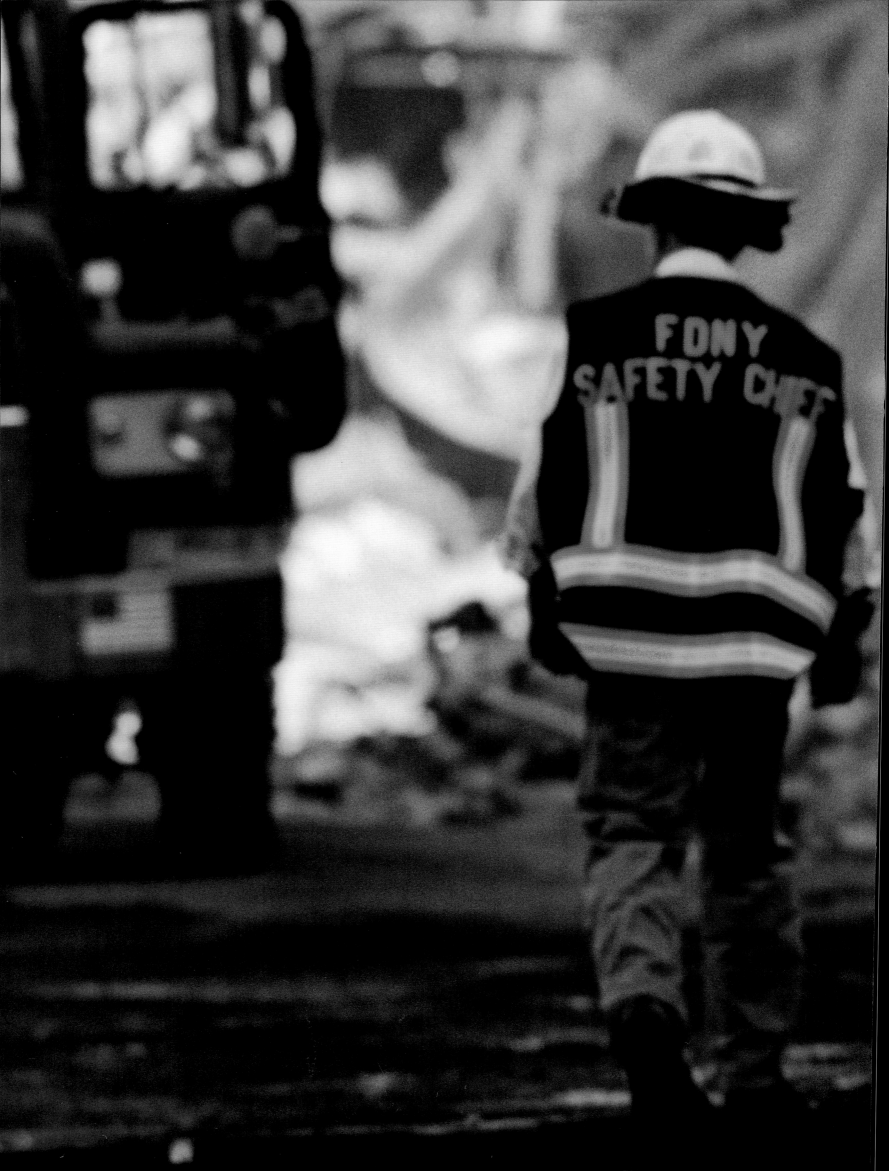

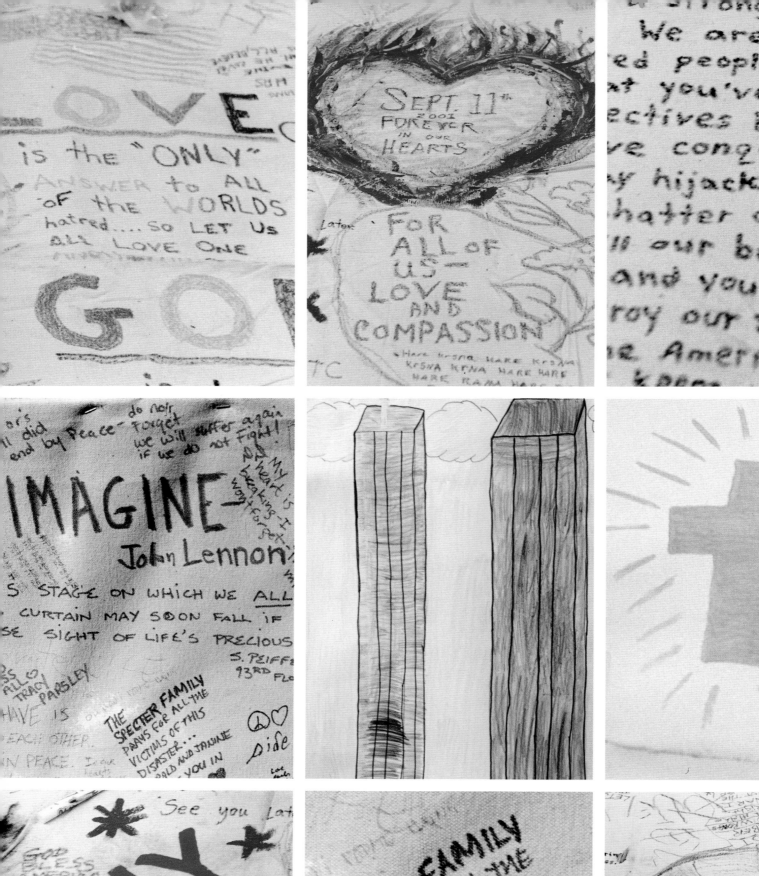

OVE is the "ONLY" ANSWER to ALL of the WORLDS hatred....SO LET Us ALL LOVE ONE GO

SEPT. 11th 2001 FOREVER IN OUR HEARTS

Latex

FOR ALL OF US— LOVE AND COMPASSION

Hare Krsna Hare Krsna
Krsna Krsna Hare Hare
Hare Rama Hare

WTC

...strong and
We are a cou
red people. You
t you've conq
ectives but in
ve conqured
y hijack our
hatter our bu
ll our bodies,
and you will
roy our spirit
e American s

ors
ll did
end by Peace
do no/s
FORGET
we will suffer again
if we do not Fight!

MY heart is breaking I won't forget

IMAGINE
John Lennon

STAGE ON WHICH WE ALL
CURTAIN MAY SOON FALL if
SE SIGHT OF LIFE'S PRECIOUS

TRACY PARSLEY

S. PEIFFE
93RD FL

HAVE IS
EACH OTHER.
IN PEACE. In our
hearts

THE SPECTER FAMILY PRAYS FOR ALL THE VICTIMS OF THIS DISASTER... GERALD AND JANINE YOU IN

peace

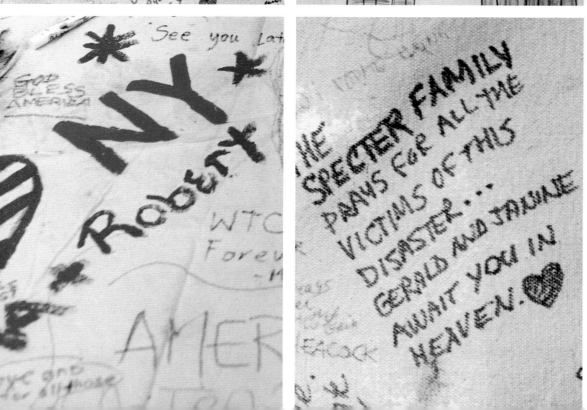

See you Lat

GOD BLESS AMERICA

NY

Robert

WTC
Forev

AMER

THE SPECTER FAMILY PRAYS FOR ALL THE VICTIMS OF THIS DISASTER... GERALD AND JANINE AWAIT YOU IN HEAVEN.

EACOCK

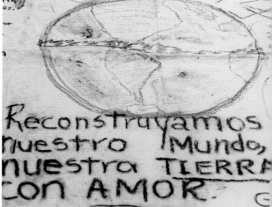

Reconstruyamos
nuestro Mundo,
nuestra TIERRA
con AMOR.

inst

WHAT woul
LUTHER

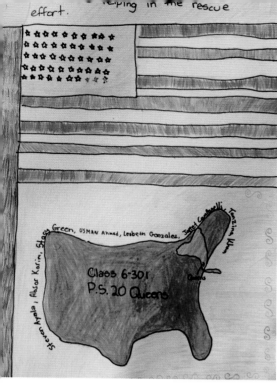
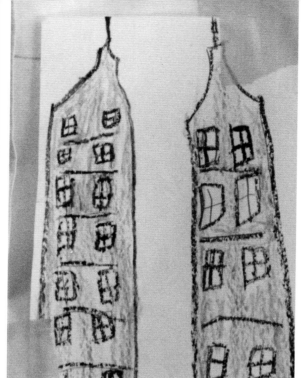
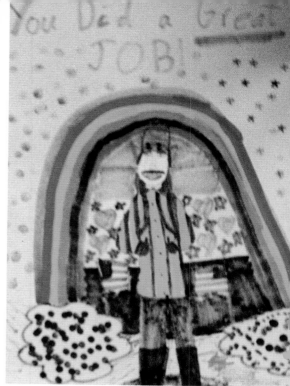
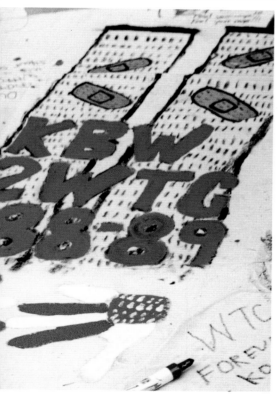
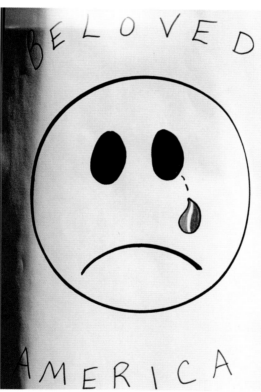

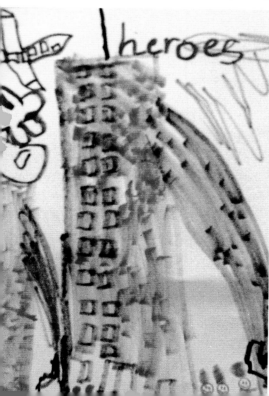
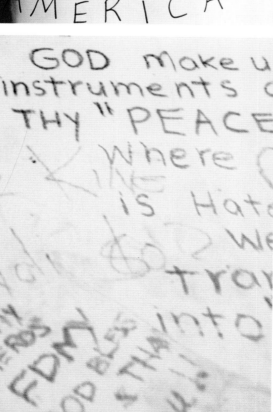
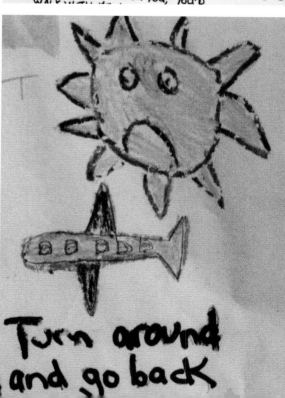

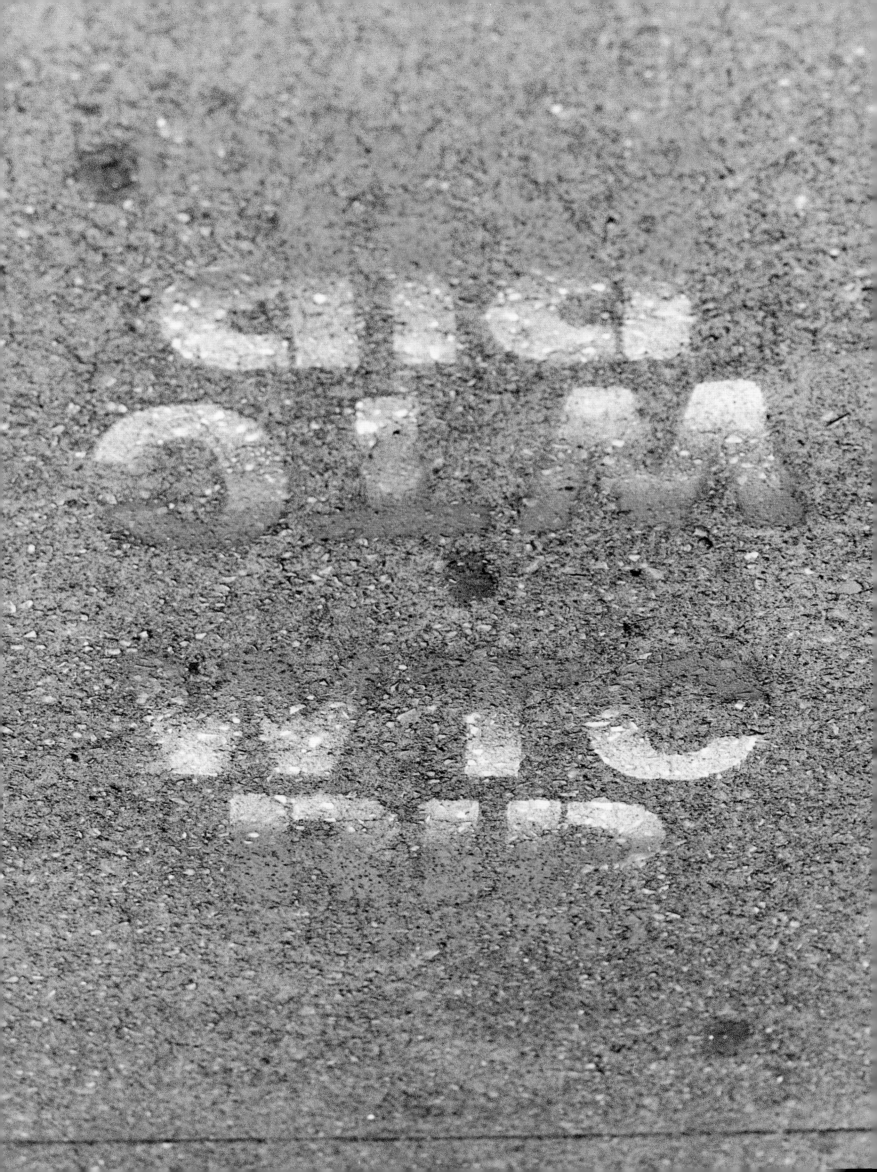

There is no limit to the variable genius of human character, the full expression of human capacity . . .

...ed. The beutiful Towers

...nger standing tall.

...those who lost their lives.

...se who lost their husbends

...ives. Fathers. mothers.

...ers and sons may their

...emain with the lord above.

...our hearts remain with

...Relatives. friends now

...Hard for us to live on with

PEACE WILL NOT COME OUT OF

...ere be no more suffering

...re crying. no more death.

...or life for breath. May

...be the begining of the end.

...we have a shoulder to lean

...riend. May we keep

...ng eachother caring for

...oneanother

...we be able to be in peace.

...or more survivers we

112

Every Night

No more lives torn
apart
That wars will never
start
And times will heal our
hearts
Everyone will have a
friend
And right will always

CLASH OF ARMS BUT OF JUSTICE LIVED.

This is what I pray for
Every Night
Hopeing to never see that
Sight
That sight of
death
Trying to get
Breath
So prey for

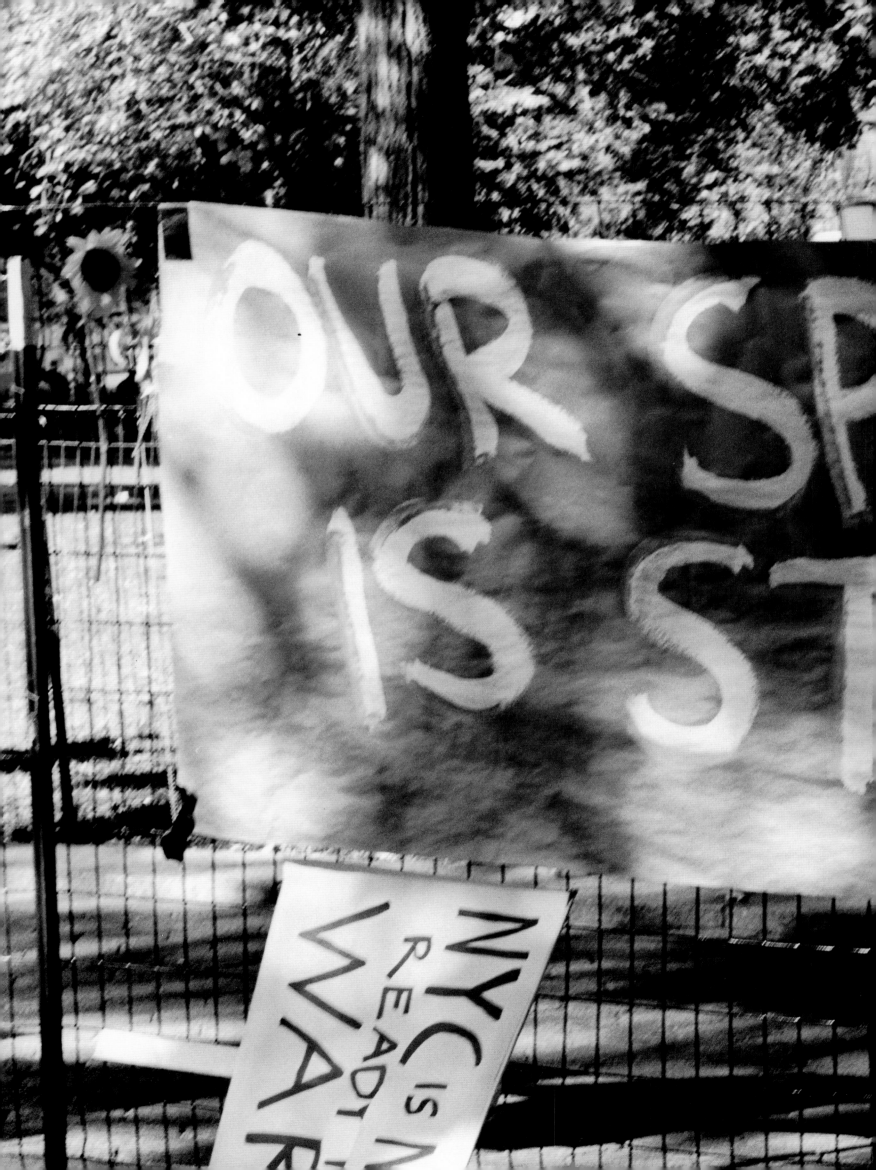

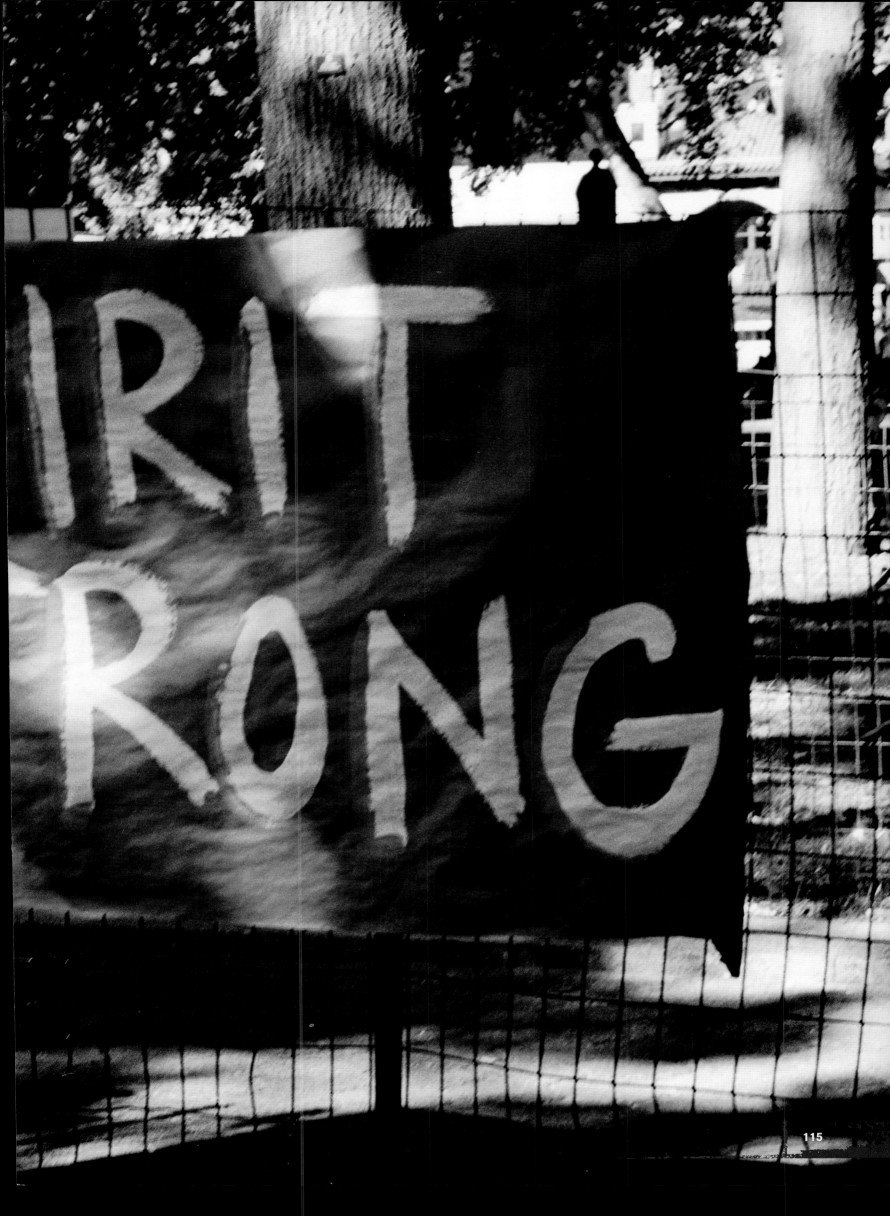

it will report the universe with endless ascription, infinite surprise . . .
and this conviction too we shared, and all of them together comprised
the metropolitan oversoul in which we moved and lived.

Lee this serve us together...

Attack on America

It is 8:45, Tuesday, September 11, 2001. A normal day for many commuters, students and workers in that general area. Minutes later, a commercial airliner screamed overhead, altitude dropping sharply. The Boeing 767 Jumbo Jet slams headlong into the upper floors of Tower One of the World Trade Center. Several minutes later, a second plane shattered the middle levels of Tower 2, and within the course of an hour, the most distinguishing characteristics of the New York City Skyline was reduced to rubble. Soon after the Pentagon had been attacked, as were other prime targets.

Mixed feelings entered the hearts of the American people after word of the attack spread. Anger toward who mercilessly slaughtered American victims. Sorrow for the families who lost loved ones to this terrorist tragedy. And strangely, a feeling of triumph, and hope. Triumph, because the terrorists failed. Triumph, because the American people can rebuild. Triumph, because the resolve of the American people will prevail, once again.

Carlo
11 years old
09-12-01

GOD BLESS AMERICA

GOD BLESS AMERICA
GOD BLESS NEW YORK

GOD BLESS NEW YORK

TO: NEW YORK
BRAVE

NEW YORK CITY TH
YOUR COURAGE AND
IN OUR TIME OF
DAY YOU RISK YOU

YOUR BRAVERY RES
AN ANGEL IN TH
BE VICTIMS TO DE
YOU FALL IN TH

NEW YORK CITY'S
BE KNOWN AS N
ANG

CITY'S
ST

ANKS YOU FOR
YOUR BRAVERY
NEED, AND EVERY
LIFE FOR OURS.

MBLES THAT OF
EYES OF WOULD
ASTATION AND WHEN
LINE OF DUTY.

RAVEST SHOULD
W YORK CITY'S

LS
MAY GOD BLESS
YOU...
FD

Killer, when in your malignity, and in the evil illusion of your righteousness, you did this hideous damned thing, our thousands of dead were transfigured, and in their names and numbers they stand now for our Democracy. So that even as we mourn them, we know that they are our endowment, and that the multiplicity of our voices assures the creation of a self-revising, consensual reality that inches forward over generations to an enlightened forbearing relationship among human beings

. . . and a dream of truth.

E. L. DOCTOROW

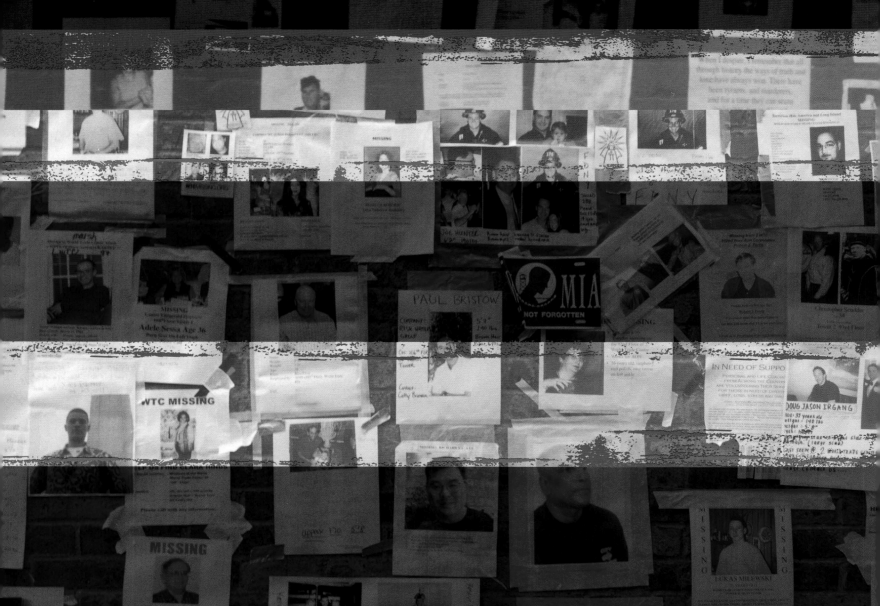

GOD BE
WITH YOU
WE LOVE YOU

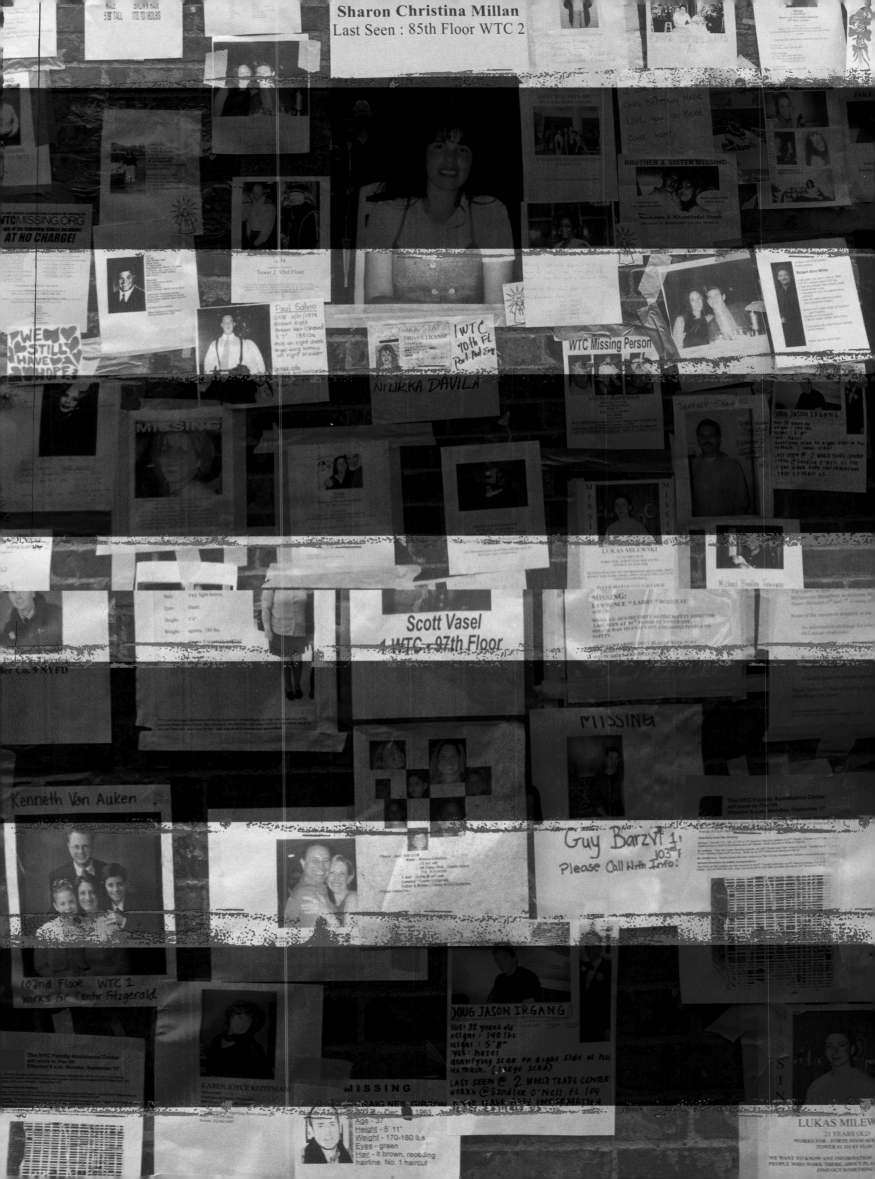

Gordon McCannel Aamoth Jr. _ Maria Rose Abad _ Edelmiro "Ed" Abad _ Andrew Anthony Abate _ Vincent Abate _ William F. Abrahamson _ Ric
Adams _ Stephen Adams _ Donald L. Adams _ Ignatius Adanga _ Christy A. Addamo _ Terence E. Adderley Jr. _ Sophia Buruwa Addo _ Lee Adle
G. Ahearn _ Jeremiah J. Ahern _ Joanne Ahladiotis _ Shabbir Ahmed _ Terrance Aiken _ Godwin Ajala _ Gertrude M. Alagero _ Andrew Alame
Boutros al-Hashim _ Ernest Alikakos _ Edward L. Allegretto _ Eric T. Allen _ Joseph Ryan Allen _ Richard D. Allen _ Richard L. Allen _ Christophe
Cesar Alviar _ Tariq Amanullah _ Angelo Amaranto _ James Amato _ Joseph Amatuccio _ Paul Ambrose _ Christopher Charles Amoroso _ Spo
Michael R. Andrews _ Jean A. Andrucki _ Siew-Nya Ang _ Joseph Angelini Jr. _ Joseph Angelini Sr. _ Lynn Edwards Angell _ David Lawrence An
Aquilino _ Patrick Michael Aranyos _ David Arce _ Michael G. Arczynski _ Louis Arena _ Barbara Jean Ares Tequi _ Adam Arias _ Michael Joseph A
Edward Asher _ Janice Ashley _ Thomas J. Ashton _ Manuel O. Asitimbay _ Lt. Gregg Arthur Atlas _ James Audiffred _ Louis Frank Aversano Jr. _
_ Robert J. Baierwalter _ Garnet Edward "Ace" Bailey _ Andrew J. Bailey _ Brett T. Bailey _ Tatyana Bakalinskaya _ Michael Baksh _ Sharon Balko
Fairbanks Barbosa _ Christine Barbuto _ Colleen Ann Barkow _ David Barkway _ Melissa Rose Barnes _ Matthew E. Barnes _ Sheila P. Barnes _
_ Alysia Basmajian _ Kenneth W. Basnicki _ Lt. Steven J. Bates _ Paul James Battaglia _ W. David Bauer _ Marlyn C. Bautista _ Ivhan Luis Carpi
A. Beaven _ Lawrence I. Beck _ Manette Marie Beckles _ Carl John Bedigian _ Michael E. Beekman _ Maria Asuncion Behr _ (Retired) Master
Denise Lenore Benedetto _ Domingo Benilda _ Eric L. Bennett _ Bryan Craig Bennett _ Margaret L. Benson _ Dominick J. Berardi _ James P. B
Bernard _ William H. Bernstein _ David M. Berray _ Joseph John Berry _ David S. Berry _ William Reed Bethke _ Yeneneh Betru _ Timothy D. B
Biggart _ Mark K. Bingham _ Carl V. Bini _ Gary Bird _ Joshua David Birnbaum _ George John Bishop _ Kris Romeo Bishundat _ Jeffrey D. Bittn
Rita Blau _ Richard M. Blood Jr. _ Michael A. Boccardi _ John Paul Bocchi _ Michael L. Bocchino _ Susan M. Bochino _ Deora Frances Bodley _
Bondarenko _ Andre Bonheur Jr. _ Colin Bonnett _ Yvonne Bonomo _ Frank Bonomo _ Genieve Bonsignore _ Sean Booker _ Kelly Ann Booms
Bosco _ Klaus Bothe _ Carol Marie Bouchard _ J. Howard Boulton Jr. _ Francisco Bourdier _ Thomas H. Bowden Jr. _ Donna Bowen _ Veronique
Boyce _ Allen Boyle _ Michael Boyle _ Alfred J. Braca _ Sandra Conaty Brace _ Kevin H. Bracken _ Sandra W. Bradshaw _ David Brian Brady _ Ale
Breitweiser _ Francis Henry Brennan _ Peter Brennan _ Michael Emmett Brennan _ Thomas M. Brennan _ Edward A. Brennan III _ Capt. Danie
Herman C. Broghammer _ Keith Alexander Broomfield _ Capt. Patrick J. Brown _ Bernard Curtis Brown II _ Janice J. Brown _ Lloyd Brown _ Be
Nancy Bueche _ Patrick Joseph Buhse _ John E. Bulaga Jr. _ Stephen Bunin _ Christopher Lee Burford _ Matthew J. Burke _ Thomas Daniel Burl
Burnside _ Irina Buslo _ Milton Bustillo _ Thomas M. Butler _ Timothy G. Byrne _ Daniel M. Caballero _ Jesus N. Cabezas _ Lillian Caceres _ Bri
_ George Cain _ Salavatore Calabro _ Joseph Calandrillo _ Philip V. Calcagno _ Edward Calderon _ Sgt. 1st Class Jose Orlando Calderon-Olme
Campbell _ Robert Arthur Campbell _ David O. Campbell _ Jill Marie Campbell _ Geoffrey Thomas Campbell _ Juan Ortega Campos _ Sean Ca
Jonathan N. Cappello _ James Christopher Cappers _ Richard Caproni _ Jose Cardona _ Dennis M. Carey _ Edward Carlino _ Michael Carlo _
James J. Carson Jr. _ Christoffer Mikael Carstanjen _ Angelene C. Carter _ Christopher Newton Carter _ James Marcel Cartier _ Sharon Carver
Alejandro Castano _ Arcelia Castillo _ Leonard M. Castrianno _ Jose R. Castro _ William E. Caswell _ Richard G. Catarelli _ Christopher Sean C
Carter _ Jason Cefalu _ Thomas J. Celic _ Ana M. Centeno _ Joni Cesta _ John J. Chada _ Jeffrey M. Chairnoff _ Swarna Chalasini _ William Chalco
MacMillan Cherry _ Vernon Paul Cherry _ Stephen Patrick Cherry _ Swede Joseph Chevalier _ Nestor Chevalier _ Alexander H. Chiang _ Doroth
Chirls _ Abul K. Chowdhury _ Mohammed Salahuddin Chowdhury _ Kirsten L. Christophe _ Pamela Chu _ Steven P. Chucknick _ Wai-ching Chu
Clark _ Sarah M. Clark _ Benjamin Keefe Clark _ Gregory A. Clark _ Mannie Leroy Clark _ Thomas R. Clark _ Christopher Robert Clarke _ Micha
Patricia A. Cody _ Jason Matthew Coffey _ Daniel Michael Coffey _ Florence Cohen _ Kevin S. Cohen _ Anthony J. Coladonato _ Mark J. Colaio _
Joseph Colhoun _ Robert D. Colin _ Robert Joseph Coll Jr. _ Jean Marie Collin _ Thomas J. Collins _ John M. Collins _ Michael Collins _ Jeffrey (
Clancy Conlon _ Margaret Mary Conner _ Cynthia L. Connolly _ John E. Connolly _ James Lee Connor _ Jonathan Connors _ Kevin P. Connors _
Joseph Coppo Jr. _ Gerald J. Coppola _ Joseph A. Corbett _ John Corcoran III_ Alejandro Cordero _ Robert Cordice _ Ruben Correa _ Daniel Cor
G. Costello Jr. _ Asia Cottom _ Conrod K.H. Cottoy Sr. _ Martin Coughlan _ Sgt. John Coughlin _ Timothy John Coughlin _ James E. Cove _ And
Cranford _ Denise Crant _ Robert James Crawford _ James Crawford Jr. _ Tara Kathleen Creamer _ Joanne Cregan _ Lucy Crifasi _ Lt. John Cris
Cruikshank _ John Robert Cruz _ Francisco Cruz Sr. _ Kenneth John Cubas _ Francisco C. Cubero _ Thelma Cuccinello _ Richard Joseph Cudina
_ Robert Curatolo _ Laurence D. Curia _ Paul Curioli _ Patrick Currivan _ Beverly L. Curry _ Sgt. Michael Curtin _ Patricia Cushing _ Gavin Cushny
_ Jack L. D'Ambrosi Jr. _ Jeannine Marie Damiani-Jones _ Patrick W. Danahy _ Mary D'Antonio _ Vincent G. Danz _ Dwight D. Darcy _ Elizabeth A
Davidson _ Niurka Davila _ Wayne T. Davis _ Ada Davis _ Clinton Davis Sr. _ Anthony Richard Dawson _ Calvin Dawson _ Edward Day _ Ana G
DeAngelis Jr. _ Dorothy Alma DeAraujo _ Tara Debek _ James D. Debeuneure _ Anna Debin _ James Vincent DeBlase _ Paul DeCola _ Lt. Ge
Delapenha _ Vito J. Deleo _ Danielle Delie _ Joseph Della Pietra _ Palmina Delli Gatti _ Colleen Ann Deloughery _ Joseph Deluca _ Manuel Del V
Depena _ Robert Deraney _ Michael DeRienzo _ David P. DeRubbio _ Jemal Legesse DeSantis _ Christian D. DeSimone _ Edward DeSimone III
Di Franco _ Michael L. DiAgostino _ Matthew Diaz _ Lourdes Galleti Diaz _ Nancy Diaz _ Obdullo Ruiz Diaz _ Michael A. Diaz-Piedra III _ Judith
D. Diehl _ John DiFato _ Vincent Francis DiFazio _ Donald J. DiFranco _ Carl A. DiFranco _ Alexandra Costanza Digna _ Eddie Dillard _ Debra
DiPasquale _ Joseph DiPilato _ Douglas F. DiStefano _ Donald Americo DiTullio _ Ramzi Doany _ Johnnie Doctor Jr. _ John J. Doherty _ Melissa
_ Comdr. William Howard Donovan Jr. _ Stephen S. Dorf _ Thomas Dowd _ Lt. Kevin Dowdell _ Mary Yolanda Dowling _ Raymond M. Downey _
_ Thomas W. Duffy _ Michael Joseph Duffy _ Christopher Michael Duffy _ Gerard Duffy _ Antoinette Duger _ Sareve Dukat _ Comdr. Patrick S. Du
Eaton _ Dean Eberling _ Margaret Echtermann _ Paul Eckna _ Constantine Economos _ Barbara G. Edwards _ Dennis Michael Edwards Jr. _ Mi
Eisenberg _ Daphne Elder _ Michael Elferis_ Mark Ellis _ Valerie Ellis _ Albert Elmarry _ Lt. Cmdr. Robert R. Elseth _ Edgar Emery Jr. _ Doris Suk-Y
_ William Esposito _ Ruben Esquilin Jr. _ Sadie Ette _ Barbara Etzold _ Eric Evans _ Robert Evans _ Meredith Ewart _ Catherine K. Fagan _ Patr
Anthony J. Fallone Jr. _ Dolores B. Fanelli _ Robert J. Fangman _ John J. Fanning _ Kathleen Ann Faragher _ Capt. Thomas Farino _ Nancy Care
Joseph Farrelly _ Thomas P. Farrelly _ Syed Abdul Fatha _ Christopher E. Faughnan _ Wendy R. Faulkner _ Shannon M. Fava _ Bernard D. Favu
Feinberg _ Rosa M. Feliciano _ Edward P. Felt _ Edward T. Fergus Jr. _ George J. Ferguson _ James Joe Ferguson _ Henry Fernandez _ Judy Haze
_ Bradley J. Fetchet _ Jennifer Louise Fialko _ Kristen Fiedel _ Amelia Fields _ Samuel Fields _ Alexander M. Filipov _ Michael Bradley Finnegan _
R. Fisher _ Gerald P. Fisher _ Thomas J. Fisher _ Lucy Fishman _ Ryan Fitzgerald _ Doug Fitzgerald _ Tom Fitzpatrick _ Richard P. Fitzsimons _
Flocco _ John Joseph Florio _ Joseph W. Flounders _ Carol Flyzik _ David Fodor _ Capt. Michael N. Fodor _ Steven Mark Fogel _ Thomas Foley _
_ Claudia Alicia Foster _ Noel J. Foster _ Sandra N. Foster _ Ana Fosteris _ Robert Foti _ Jeffrey L. Fox _ Virginia Fox _ Pauline Francis _ Virgin F
Lillian I. Frederick _ Andrew A. Fredericks _ Jamitha Freeman _ Brett O. Freiman _ Lt. Peter Freund _ Arlene E. Fried _ Alan Wayne Friedlander _
Furmato _ Karleton D.B. Fyfe _ Fredric Neal Gabler _ Richard P. Gabriel Sr. _ Richard S. Gabrielle _ James Andrew Gadiel _ Pamela Gaff _ Ervin
_ Thomas Edward Galvin _ Giovanna Gambale _ Thomas Gambino Jr. _ Giann Gamboa _ Ronald Gamboa _ Peter J. Ganci Jr. _ Claude Gann _ Lt
_ William Arthur Gardner _ Thomas Gardner _ Douglas B. Gardner _ Christopher Gardner _ Harvey J. Gardner III _ Francesco Garfi _ Rocco Ga
Hamilton Geier _ Julie M. Geis _ Peter Gelinas _ Steven P. Geller _ Howard G. Gelling Jr. _ Peter V. Genco _ Steven G. Genovese _ Alayne F. Ger
Getzendanner _ Capt. Lawrence Daniel Getzfred _ James Gerard Geyer _ Cortez Ghee _ Joseph M. Giaconne _ Lt. Vincent F. Giammona _ Deb
Stuart Gilbey _ Paul J. Gill _ Mark Y. Gilles _ Evan Hunter Gillette _ Ronald Gilligan _ Sgt. Rodney Gillis _ Laura Gilly _ Lt. John Ginley _ Jeffrey Gio

hony Aceto _ Jesus Acevedo Rescand _ Heinrich B. Ackermann _ Paul Andrew Acquaviva _ Shannon Lewis Adams _ Christian Adams _ Patrick
el Thomas Afflitto _ Emmanuel Afuakwah _ Alok Agarwal _ Mukul K. Agarwala _ Joseph Agnello _ David Agnes _ Joao A.D. Aguiar Jr. _ Lt. Brian
rgaret Jezycki Alario _ Gary Albero _ Jon L. Albert _ Peter Craig Alderman _ Jacquelyn D. Aldridge _ Grace Alegre-Cua _ David Dewey Alger _
ngham _ Anna Williams Allison _ Janet M. Alonso _ Anthony Joshua Alvarado _ Juan Cisneros Alvarez _ Antonio Javier Alvarez _ Telmo Alvear _
Amundson _ Kazuhiro Anai _ Calixto "Charlie" Anaya Jr. _ Joseph P. Anchundia _ Kermit C. Anderson _ Yvette Anderson _ John Andreacchio _
aura Angilletta _ Doreen J. Angrisani _ Lorraine Del Carmen Antigua _ Seima Aoyama _ Peter P. Apollo _ Faustino Apostol Jr. _ Frank Thomas
ng _ Joshua Todd Aron _ Jack Charles Aron _ Richard A. Aronow _ Myra Joy Aronson _ Japhet J. Aryee _ Carl Asaro _ Michael A. Asciak _ Michael
wiles _ Alona Avraham _ Samuel "Sandy" Ayala _ Arlene T. Babakitis _ Eustace "Rudy" Bacchus _ John James Badagliacca _ Jane Ellen Baeszler _
chael Andrew Bane _ Kathy Bantis _ Gerard Jean Baptiste _ Walter Baran _ Gerald Barbara _ Paul V. Barbaro _ James W. Barbella _ Ivan Kryllos
_ Baron _ Renee Barrett-Arjune _ Arthur T. Barry _ Diane Barry _ Maurice V. Barry _ Scott D. Bart _ Carlton W. Bartels _ Guy Barzvi _ Inna Basina
sta _ Mark Lawrence Bavis _ Jasper Baxter _ Lorraine G. Bay _ Michele DuBerry Beale _ Todd Beamer _ Paul F. Beatini _ Jane S. Beatty _ Alan
x Beilke _ Yelena Belilovsky _ Nina Patrice Bell _ Andrea Della Bella _ Debbie S. Bellows _ Stephen Elliott Belson _ Paul Michael Benedetti _
Steven Howard Berger _ John P. Bergin _ Alvin Bergsohn _ Daniel D. Bergstein _ Graham Andrew Berkeley _ Donna Bernaerts-Kearns _ Dave
Carolyn Mayer Beug _ Edward F. Beyea _ Paul Beyer _ Anil T. Bharvaney _ Bella Bhukhan _ Shimmy D. Biegeleisen _ Peter Bielfield _ William
ewa Albert Blackman _ Christopher Blackwell _ Carrie Blagburn _ Susan L. Blair _ Harry Blanding Jr. _ Janice L. Blaney _ Craig Michael Blass _
. Boehm _ Mary Katherine Boffa _ Nicholas A. Bogdan _ Darren C. Bohan _ Lawrence F. Boisseau _ Vincent Boland Jr. _ Touri Bolourchi _ Alan
ol. Canfield D. Boone _ Mary Jane Booth _ Sherry Bordeaux _ Krystine C. Bordenabe _ Diana Borrero de Padro _ Martin Boryczewski _ Richard
Bowers _ Kimberly S. Bowers _ Larry Bowman _ Shawn Edward Bowman Jr. _ Kevin L. Bowser _ Gary R. Box _ Gennady Boyarsky _ Pamela J.
nsky _ Nicholas Brandemarti _ Daniel R. Brandhorst _ David Brandhorst _ Michelle Renee Bratton _ Patrice Braut _ Lydia Estelle Bravo _ Ronald
_ Gary L. Bright _ Jonathan Briley _ Mark A. Brisman _ Paul Bristow _ Victoria Alvarez Brito _ Marion Ruth Britton _ Mark Francis Broderick _
owne _ Mark Bruce _ Richard Bruehert _ Andrew Brunn _ Ronald Paul Bucca _ Brandon J. Buchanan _ Greg Joseph Buck _ Dennis Buckley _
ot. William F. Burke Jr. _ Charles F. Burlingame _ Thomas E. Burnett Jr. _ Keith James Burns _ Donald J. Burns _ Kathleen A. Burns _ John Patrick
nia _ Steven Cafiero Jr. _ Richard M. Caggiano _ Cecile M. Caguicla _ Michael John Cahill _ John Brett Cahill _ Thomas J. Cahill _ Scott W. Cahill
nneth Caldwell _ Dominick Enrico Calia _ Liam Callahan _ Suzanne Calley _ Luigi Calvi _ Roko Camaj _ Michael Cammarata _ Sandra Patricia
_ John A. Candela _ Vincent A. Cangelosi _ Stephen J. Cangialosi _ Lisa Cannava _ Brian Cannizzaro _ Michael R. Canty _ Louis A. Caporicci _
. Carlone _ Rosemarie C. Carlson _ Mark Stephen Carney _ Joyce Ann Carpeneto _ Jeremy M. Carrington _ Michael T. Carroll _ Peter Carroll _
Casalduc _ John F. Casazza _ Paul Cascio _ Neilie Anne Heffernan Casey _ William Joseph Cashman _ Thomas Casoria _ William O. Caspar _
Robert J. Caufield _ Mary Teresa Caulfield _ Judson J. Cavalier _ Michael Cawley _ Jason D. Cayne _ Juan Armando Ceballos _ Marcia G. Cecil-
arles Chan _ Mandy Chang _ Rosa Maria Chapa _ Mark L. Charette _ David M. Charlebois _ Gregorio Chavez _ Pedro Francisco Checo _ Douglas
archiaro _ Luis Alfonso Chimbo _ Robert Chin _ Wing-Wai Ching _ Nicholas Chiofalo Jr. _ John Chipura _ Peter A. Chirchirillo _ Catherine Ellen
hristopher Ciafardini _ Alex F. Ciccone _ Frances Ann Cilente _ Elaine Cillo _ Edna Cintron _ Nestor Andre Cintron _ Lt. Robert D. Cirri _ Eugene
e _ Suria R.E. Clarke _ Donna Clarke _ Kevin Francis Cleary _ Jim Cleere _ Geoffrey Cloud _ Susan M. Clyne _ Steven Coakley _ Jeffrey Coale _
en J. Colaio _ Christopher M. Colasanti _ Kevin N. Colbert _ Michel Paris Colbert _ Keith E. Coleman _ Scott T. Coleman _ Tarel Coleman _ Liam
_ Patricia Malia Colodner _ Linda M. Colon _ Soledi E. Colon _ Ronald Comer _ Jaime Concepcion _ Albert Conde _ Denease Conley _ Susan
F. Conroy _ Brenda E. Conway _ Helen D. Cook _ Dennis Michael Cook _ Jeffrey W. Coombs _ Julian Cooper _ Zandra Cooper _ John Cooper _
ierrez _ James Corrigan _ Georgine Rose Corrigan _ Carlos Cortes _ Kevin M. Cosgrove _ Dolores Marie Costa _ Michael S. Costello _ Charles
_ Frederick John Cox Jr. _ James Raymond Coyle _ Michelle Coyle-Eulau _ Anne Martino Cramer _ Christopher S. Cramer _ Lt. Cmdr. Eric Allen
niel Crisman _ Dennis Cross _ Helen P. Crossin-Kittle _ Thomas G. Crotty _ Kevin R. Crotty _ John R. Crowe _ Welles Remy Crowther _ Robert L.
James Cudmore _ Thomas Patrick Cullen III _ Joan McConnell Cullinan _ Joyce Cummings _ Brian Thomas Cummins _ Michael J. Cunningham
el J. Da Mota _ Caleb Arron Dack _ Carlos S. DaCosta _ Jason Dahl _ Brian P. Dale _ John D'Allara _ Vincent D'Amadeo _ Thomas A. Damaskinos
ing _ Annette Andrea Dataram _ Lt. Edward Alexander D'Atri _ Michael D'Auria _ Lawrence Davidson _ Michael Allen Davidson _ Scott Matthew
casangre de Barrera _ Jayceryll M. de Chavez _ Emerita de la Pena _ Azucena de la Torre _ William T. Dean _ Thomas P. Deangelis _ Robert J.
ncis Deconto _ Simon Dedvukaj _ Jason DeFazio _ David A. Defeo _ Jennifer DeJesus _ Nereida DeJesus _ Monique E. DeJesus _ Donald A.
Anthony Demas _ Martin DeMeo _ Frank Xavier Deming _ Carol K. Demitz _ Thomas Dennis _ Kevin Dennis _ Jean C. DePalma _ Jose Nicholas
drew Desperito _ Michael J. D'Esposito _ Cindy Ann Deuel _ Jerry DeVito _ Robert P. Devitt Jr. _ Dennis Lawrence Devlin _ Gerard Dewan _ Carl
Diaz-Sierra _ Patricia F. DiChiaro _ Rodney Dickens _ Lt. Col. Jerry Don Dickerson _ Joseph D. Dickey Jr. _ Lawrence Patrick Dickinson _ Michael
Martino _ David DiMeglio _ Stephen P. Dimino _ William J. Dimmling _ Christopher Dincuff _ Jeffrey M. Dingle _ Anthony DiOnisio Jr. _ George
Brendan Dolan _ Capt. Robert Edward Dolan _ Neil Dollard _ James Domanico _ Alberto Dominguez _ Lt. Kevin Donnelly _ Jacqueline Donovan
M. Doyle _ Frank J. Doyle _ Randy Drake _ Stephen Patrick Driscoll _ Patrick Joseph Driscoll _ Charles Droz _ Mirna A. Duarte _ Luke A. Dudek
ristopher Joseph Dunne _ Richard A. Dunstan _ Patrick Thomas Dwyer _ Joseph Eacobacci _ John Eagleson _ Edward Thomas Earhart _ Robert
dwards _ Christine Egan _ Lisa Egan _ Capt. Martin Egan Jr. _ Michael Egan _ Samantha Egan _ Carol Eggert _ Lisa Ehrlich _ John Eichler _ Eric
g _ Ulf Ericson _ Erwin Erker _ William Erwin _ Sarah Escarcega _ Fanny Espinoza _ Bridgette Esposito _ Francis Esposito _ Lt. Michael Esposito
agan _ Keith Fairben _ Zoe Falkenberg _ Charles S. Falkenberg _ Dana Falkenberg _ Jamie Lynn Fallon _ William Fallon _ William F. Fallon Jr. _
ey _ Paige Farley-Hackel _ Elizabeth Ann Farmer _ Douglas J. Farnum _ Terrence Patrick Farrell _ John G. Farrell _ John William Farrell _ Capt.
Ronald C. Fazio _ Robert Fazio Jr. _ William Feehan _ Francis Feely _ Garth E. Feeney _ Sean Fegan _ Lee S. Fehling _ Peter Feidelberg _ Alan
ndez _ Elisa Giselle Ferraina _ Anne Marie Sallerin Ferreira _ Robert John Ferris _ David Francis Ferrugio _ Louis V. Fersini Jr. _ Michael Ferugio
thy J. Finnerty _ Michael Fiore _ Stephen J. Fiorelli _ Paul Fiori _ John Fiorito _ John Fischer _ Andrew Fisher _ Bennett Lawson Fisher _ Lt. John
re A. Fiumefreddo _ Darlene Flagg _ Wilson Flagg _ Christina Flannery _ Eileen Flecha _ Andre Fletcher _ Carl M. Flickinger _ Matthew Michael
ger _ David Fontana _ Chih Min "Dennis" Foo _ Del Rose Forbes-Cheatham _ Godwin Forde _ Donald A. Foreman _ Christopher Hugh Forsythe
Gary J. Frank _ Peter Christopher Frank _ Morton Frank _ Richard K. Fraser _ Colleen Laura Fraser _ Kevin Joseph Frawley _ Clyde Frazier Jr. _
K. Friedman _ Paul J. Friedman _ Gregg J. Froehner _ Lisa Frost _ Peter Christian Fry _ Clement Fumando _ Steven Elliott Furman _ Paul James
d _ Grace Galante _ Deanna L. Galante _ John Patrick Gallagher _ Daniel J. Gallagher _ Anthony E. Gallagher _ Cono E. Gallo _ Vincent Gallucci
s William Garbarini _ Marlyn del Carmen Garcia _ Cesar Garcia _ David Garcia _ Andrew Garcia _ Jorge Garcia _ Juan Garcia _ Jeffrey B. Gardner
_ James Gartenberg _ Matthew David Garvey _ Bruce Gary _ Boyd A. Gatton _ Donald R. Gavagan Jr. _ Peter A. Gay _ Terence Gazzani _ Paul
nda M. George _ Edward Geraghty _ Suzanne Geraty _ Ralph Gerhardt _ Robert J. Gerlich _ Denis P. Germain _ Marina R. Gertsberg _ Susan M.
bbon _ James Giberson _ Brenda C. Gibson _ Craig Gibson _ Ronnie Gies _ Laura Giglio _ Timothy Paul Gilbert _ Andrew Clive Gilbert _ Paul
John Giordano _ Donna Marie Giordano _ Steven A. Giorgetti _ Martin Giovinazzo Jr. _ Kum-Kum Girolamo _ Salvatore Gitto _ Cynthia Giugliano

_ Mon Gjonbalaj _ Dianne Gladstone _ Keith Glascoe _ Thomas I. Glasser _ Edmund Glazer _ Harry Glenn _ Jeremy Glick _ Barry H. Glick _

Goldstein _ Michelle Herman Goldstein _ Andrew H. Golkin _ Dennis J. Gomes _ Enrique Antonio Gomez _ Jose B. Gomez _ Manuel Gomez _

Gopu _ Catherine Carmen Gorayeb _ Lisa Reinhart Fenn Gordenstein _ Kerene Gordon _ Sebastian Gorki _ Thomas E. Gorman Gorman _ Mic

Granados _ Lauren Grandcolas _ Winston A. Grant _ Christopher Stewart Gray _ Ian J. Gray _ James M. Gray _ Linda Mair Grayling _ John Mic

Greenberg _ Gayle R. Greene _ Donald F. Greene _ James A. Greenleaf Jr. _ Eileen Marsha Greenstein _ Elizabeth "Lisa" Gregg _ Denise Gregor

_ Joseph F. Grillo _ David Grimner _ The Rev. Francis E. Grogan _ Linda Gronlund _ Kenneth G. Grouzalis _ Joseph Grzelak _ Matthew J. Grzyma

Guman _ Douglas Brian Gurian _ Janet H. Gustafson _ Philip T. Guza _ Barbara Guzzardo _ Peter Gyulavary _ Gary Robert Haag _ Andrea Habe

_ Diane Hale-McKinzy _ Stanley Hall _ Vaswald G. Hall _ Richard B. Hall _ Robert John Halligan _ Lt. Vincent Halloran _ Carolyn Halmon _ Jame

Hanna _ Thomas Hannafin _ Kevin J. Hannaford _ Michael L. Hannan _ Dana Hannon _ Peter Hanson _ Christine Hanson _ Vassilios Haramis _

Aisha Harris _ Stewart D. Harris _ John P. Hart _ Eric Samadikan Hartono _ John Clinton Hartz _ Emeric J. Harvey _ Peter Hashem _ Timothy Has

_ Donald G. Havlish Jr. _ Nobuhiro Hayatsu _ James E. Hayden _ Philip Thomas Hayes _ Robert J. Hayes _ William Ward Haynes _ Scott Haze

oseph Heller Jr. _ JoAnn L. Heltibridle _ Mark F. Hemschoot _ Ronnie Lee Henderson _ Janet Hendricks _ Edward R. Hennessey Jr. _ Brian He

Herkness III _ Harvey Hermer _ Claribel Hernandez _ Norberto Hernandez _ Gary Herold _ Andy Herrera _ Jeffrey A. Hersch _ Thomas Hetze

Hobbs _ Tara Yvette Hobbs _ James L. Hobin _ Robert Wayne Hobson III _ DaJuan Hodges _ Ronald Hoerner _ Patrick A. Hoey _ John A. Hofer

Hogan Jr. _ Thomas Warren Hohlweck Jr. _ Jonathan R. Hohmann _ John Holland _ Cora Hidalgo Holland _ Joseph Francis Holland III _ Jimmie

_ Michael Horn _ Matthew D. Horning _ Robert L. Horohoe Jr. _ Michael R. Horrocks _ Aaron Horwitz _ Charles Joseph Houston _ Uhuru Gonja

Marian Hrycak _ Paul R. Hughes _ Kris R. Hughes _ Timothy Robert Hughes _ Melissa H. Hughes _ Thomas F. Hughes Jr. _ Robert T. Hughes Jr

_ Lt. Col. Stephen Neil Hyland Jr. _ Robert J. Hymel _ Capt. Walter Hynes _ Joseph Ianelli _ Zuhtu Ibis _ Jonathan Lee Ielpi _ Michael Patrick Ike

nnella _ Stephanie V. Irby _ Douglas Irgang _ Kristy Irvine-Ryan _ Todd A. Isaac _ Erik Hans Isbrandtsen _ William Iselepis Jr. _ Taizo Ishikawa

_ Bryan C. Jack _ Brooke Jackman _ Ariel Louis Jacobs _ Jason K. Jacobs _ Michael Grady Jacobs _ Aaron Jacobs _ Steven A. Jacobson _ Steve

N. Jarret _ Mohammed Jawara _ Maxima Jean-Pierre _ Francois Jean-Pierre _ Paul E. Jeffers _ John Charles Jenkins _ Joseph Jenkins Jr. _ Alan

M. Johnson _ Scott Johnson _ LaShawna Johnson _ William Johnston _ Linda Jones _ Brian Jones _ Christopher Jones _ Charles E. Jones _ Allison

_ Albert Joseph _ Ingeborg Joseph _ Karl H. Joseph _ Stephen Joseph _ Jane Eileen Josiah _ Lt. Anthony Jovic _ Angel L. Juarbe Jr. _ Karen S.

_ Howard Lee Kane _ Jennifer L. Kane _ Joon Koo Kang _ Sheldon R. Kanter _ Deborah H. Kaplan _ Robin Kaplan _ Alvin Peter Kappelmann Jr.

Kaulfers _ Don J. Kauth Jr. _ Hideya Kawauchi _ Richard Michael Keane _ Edward T. Keane _ Lisa Kearney-Griffin _ Karol Keasler _ Barbara Keatin

H. Kelley _ Timothy C. Kelly _ Thomas R. Kelly _ James Joseph Kelly _ Maurice Patrick Kelly _ Thomas W. Kelly _ Joseph A. Kelly _ Thomas M. K

. Kerwin _ Howard Lee Kestenbaum _ Douglas Ketcham _ Ruth E. Ketler _ Boris Khalif _ Taimour Khan _ Norma Khan _ Sarah Khan _ Rajes

Kimmig _ Karen A. Kincaid _ Amy R. King _ Andrew Marshall King _ Lucille King _ Robert King Jr. _ Lisa M. King-Johnson _ Brian Kinney _ Chris

Philip Kloepfer _ Andrew Knox _ Thomas P. Knox _ Yevgeny Knyazev _ Rebecca Lee Koborie _ Deborah Kobus _ Gary Koecheler _ Frank J. Koes

_ David P. Kovalcin _ John J. Kren _ William Krukowski _ Lyudmila Ksido _ Toshiya Kuge _ Shekhar Kumar _ Kenneth Kumpel _ Frederick Kuo

_ Andrew LaCorte _ Ganesh K. Ladkat _ James P. Ladley _ Joseph Lafalce _ Jeanette LaFond-Menichino _ David LaForge _ Michael P. LaForte

amonsoff _ Robert T. Lane _ Brendan M. Lang _ Roseanne P. Lang _ Vanessa Langer _ Mary Lou Langley _ Peter Langone _ Thomas M. Lango

_ Hamidou S. Larry _ John Adam Larson _ Natalie Janis Lasden _ Gary E. Lasko _ Nicholas C. Lassman _ Paul Laszczynski _ Jeffrey Latouche

Nathaniel Lawson _ David W. Laychak _ Eugen Lazar _ James Leahy _ Lt. Joseph G. Leavey _ Neil J. Leavy _ Robert LeBlanc _ Leon Lebor _ Ker

Lee _ Hyun-joon Lee _ Kathryn Lee _ Linda C. Lee _ Daniel John Lee _ Yang-Der Lee _ Myung-woo Lee _ Dong C. Lee _ Stuart Lee _ Stephen L

_ John Robinson Lenoir _ Jorge Luis Leon _ Matthew G. Leonard _ Michael Lepore _ Charles Antoine Lesperance _ Jeffrey Earl LeVeen _ John

Lewis _ Margaret S. Lewis _ Kenneth Lewis _ Ye Wei Liang _ Orasri Liangthanasarn _ Daniel F. Libretti _ Ralph Licciardi _ Edward Lichtschein _ S

J. Linehan Jr. _ Robert Linnane _ Alan Linton _ Diane Theresa Lipari _ Lorraine Lisi _ Paul Lisson _ Vincent M. Litto _ Ming-Hao Liu _ Joseph Liv

W. Lomax _ Maj. Steve Long _ Laura M. Longing _ Salvatore Lopes _ George Lopez _ Manuel Lopez _ Luis Lopez _ Maclovio Lopez Jr. _ Joseph

Edward H. Luckett II _ Mark G. Ludvigsen _ Lee Charles Ludwig _ Sean T. Lugano _ Daniel Lugo _ Marie Lukas _ William Lum Jr. _ Michael

ynch _ Sean P. Lynch _ Terence Michael Lynch _ Farrell Peter Lynch _ Louise A. Lynch _ Michael Lynch _ Michael F. Lynch _ James Francis Lynch

_ Jan Maciejewski _ Susan A. MacKay _ Catherine Fairfax MacRae _ Richard B. Madden _ Simon Maddison _ Noell Maerz _ Jennieann Maffeo _

_ Joseph Maio _ Takashi Makimoto _ Abdu Malahi _ Myrna Maldonado-Agosto _ Debora Maldonado _ Alfred R. Maler _ Gregory James Malone

Manley _ Debra M. Mannetta _ Marion Victoria Manning _ Terence J. Manning _ James Maounis _ Alfred G. Marchand _ Joseph Marchbanks Jr.

Marino _ Kevin D. Marlo _ Jose J. Marrero _ Shelley A. Marshall _ John Marshall _ James Martello _ Michael A. Marti _ Teresa M. Martin _ Karen A.

_ Waleska Martinez Rivera _ Lizie Martinez-Calderon _ Lt. Paul Richard Martini _ Joseph A. Mascali _ Bernard Mascarenhas _ Stephen Masi _

M. Mathers _ William A. Mathesen _ Marcello Matricciano _ Margaret Mattic _ Lt. Col. Dean Mattson _ Robert D. Mattson _ Walter Matuza _ Lt. C

Keithroy Maynard _ Robert J. Mayo _ Kathy N. Mazza-Delosh _ Edward Mazzella Jr. _ Jennifer Mazzotta _ Kaaria Mbaya _ James J. McAlary Jr. _

Robert Garvin McCarthy _ Justin McCarthy _ Kevin M. McCarthy _ Stanley McCaskill _ Katie Marie McCloskey _ Tara McCloud-Gray _ Ruth McC

G. McDonnell _ John Francis McDowell Jr. _ Eamon McEneaney _ John Thomas McErlean _ Katherine McGarry-Noack _ Daniel F. McGinley _ Ma

Stacey Sennas McGowan _ Francis Noel McGuinn _ Thomas F. McGuinness Jr. _ Patrick J. McGuire _ Thomas McHale _ Keith David McHeffey _ D

_ Molly McKenzie _ Barry McKeon _ Darryl McKinney _ George Patrick McLaughlin Jr. _ Robert C. McLaughlin Jr. _ Gavin McMahon _ Robert McN

A. McShane _ Timothy Patrick McSweeney _ Martin McWilliams _ Rocco Medaglia _ Abigail Medina _ Anna Medina _ Deborah Medwig _ Damian

D. Mello _ Yelena Melnichenko _ Stuart Todd Meltzer _ Diarelia J. Mena _ Dora Menchaca _ Charles Mendez _ Lizette Mendoza _ Shevonne Me

Deborah A. Merrick _ Raymond J. Metz III _ Jill Metzler _ David R. Meyer _ Nurul Huq Miah _ William E. Micciulli _ Martin P. Michelstein _ Patricia

_ Corey Peter Miller _ Phillip D. Miller _ Michael Matthew Miller _ Robert C. Miller Jr. _ Craig James Miller _ Joel Miller _ Nicole Miller _ Henry Mille

Mircovich _ Rajesh A. Mirpuri _ Joseph Mistrulli _ Susan Miszkowicz _ Lt. Paul Thomas Mitchell _ Richard Miuccio _ Jeffrey Peter Mladenik _ Fra

r. _ Brian Patrick Monaghan _ John G. Monahan _ Franklin Monahan _ Kristen Montanaro _ Craig D. Montano _ Michael Montesi _ Carlos Alber

Carlos Morales _ Abner Morales _ John Moran _ Kathleen Moran _ Gerard "Jerry" P. Moran _ John Christopher Moran _ Lindsay S. Morehouse _

Leonel Morocho _ Dennis G. Moroney _ Odessa V. Morris _ Seth A. Morris _ Lynne Irene Morris _ Christopher M. Morrison _ Ferdinand V. Morrone

Mozzillo _ Stephen V.W. Mulderry _ Michael D. Mullan _ Peter James Mulligan _ Dennis Michael Mulligan _ Michael Joseph Mullin _ James Do

Murphy _ Charles Murphy _ Patrick S. Murphy _ Edward C. Murphy _ Brian J. Murphy _ James Thomas Murphy _ Christopher W. Murphy _ Kevin

_ Valerie Victoria Murray _ Richard Todd Myhre _ Louis J. Nacke _ Lt. Robert Nagel _ Mildred Naiman _ Takuya Nakamura _ Alexander J.R. Napie

Navarro _ Joseph M. Navas _ Francis Joseph Nazario _ Marcus R. Neblett _ Glenroy Neblett _ Rayman Neblett _ Jerome O. Nedd _ Laurence Ne

Gerard T. Nevins _ Renee Lucille Newell _ Christopher A. Newton _ Nancy Yuen Ngo _ Khang Nguyen _ Jody Tepedino Nichilo _ Kathleen Nico

Ballantine Niven _ Curtis T. Noel _ Michael Allen Noeth _ Daniel R. Nolan _ Robert Walter Noonan _ Jacqueline J. Norton _ Robert Norton _ Daniela R

James O'Brien Jr. _ Lt. Daniel O'Callaghan _ Diana J. O'Connor _ Keith K. O'Connor _ Richard J. O'Connor _ Dennis J. O'Connor Jr. _ Amy O'Doh

Lawrence Glick _ John Gnazzo _ William R. Godshalk _ Michael Gogliornella _ Brian Goldberg _ Jeffrey Goldflam _ Steven I. Goldstein _ Monica
ssa Julia Gonzalez _ Mauricio Gonzalez _ Jenine Gonzalez _ Lynn Goodchild _ Calvin J. Gooding _ Peter Morgan Goodrich _ Harry Goody _ Kiran
dward Gould _ Douglas A. Gowell _ Yuji Goya _ Jon Grabowski _ Christopher Michael Grady _ Edwin John Graf III _ David M. Graifman _ Gilbert
razioso _ Timothy G. Grazioso _ Derrick Arthur Green _ Wade Brian Green _ Wanda A. Green _ Andrew Peter Charles Curry Green _ Elaine Myra
rence M. Gregory _ Donald H. Gregory _ Pedro Grehan _ Tawanna Griffin _ John Michael Griffin _ Joan D. Griffith _ Warren Grifka _ Ramon Grihalvo
Robert Joseph Gschaar _ Liming Gu _ Richard J. Guadagno _ Jose Guadalupe _ Yan Zhu Guan _ Geoffrey E. Guja _ Lt. Joseph Gullickson _ Babita
_ Barbara M. Habib _ Philip Haentzler _ Nizam A. Hafiz _ Karen Hagerty _ Steven Hagis _ Mary Lou Hague _ David Halderman _ Maile Rachel Hale
alvorson _ Robert Hamilton _ Felicia Hamilton _ Carl Max Hammond Jr. _ Frederic Kim Han _ Christopher James Hanley _ Sean Hanley _ Valerie
s A. Haran _ Gerald F. Hardacre _ Jeffrey P. Hardy _ Timothy John Hargrave _ Frances Haros _ Lt. Harvey L. Harrell _ Lt. Stephen Gary Harrell Jr. _
Capt. Thomas T. Haskell Jr. _ Joseph John Hasson III _ Capt. Terence S. Hatton _ Leonard William Hatton Jr. _ Michael Helmut Haub _ Tim Haviland
_ Lt. Michael K. Healey _ Roberta Bernstein Heber _ Charles Francis Xavier Heeran _ John Heffernan _ Michele Heidenberger _ Sheila Hein _ H.
ey _ Michelle Marie Henrique _ Joseph Patrick Henry _ William Henry _ John C. Henwood _ Robert A. Hepburn _ Mary Herencia _ Lindsay Coates
imothy Higgins _ Robert D. Higley II _ Todd Russell Hill _ Clara V. Hinds _ Neal Hinds _ Mark Hindy _ Katsuyuki Hirai _ Heather Ho _ Thomas A.
erick J. Hoffman _ Michele L. Hoffman _ Marcia Hoffman _ Joseph Hoffman _ Stephen G. Hoffman _ Judith Florence Hofmiller _ Maj. Wallace Cole
olley _ Elizabeth Holmes _ Thomas P. Holohan Jr. _ Herbert W. Homer _ LeRoy Wilton Homer Jr. _ James Hopper _ Montgomery McCullough Hord
on _ Angela Marie Houtz _ George G. Howard _ Brady K. Howell _ Michael C. Howell _ Steven L. Howell _ Jennifer Howley _ Milagros Hromada _
an Huie _ Mychal Hulse _ John Nicholas Humber Jr. _ Kathleen Hunt _ William Christopher Hunt _ Joseph Hunter _ Peggie Hurt _ Robert R. Hussa
niel Ilkanayev _ Capt. Frederick III Jr. _ Abraham Ilowitz _ Anthony Peter Infante Jr. _ Louis Steven Inghilterra _ Christopher N. Ingrassia _ Paul W.
ed Iskandar _ Aram Iskenderian Jr. _ John Iskyan _ Kazushige Ito _ Aleksandr Valeryerich Ivantsov _ Sgt. Maj. Lacey B. Ivory _ Virginia Jablonski
acoby _ Ricknauth Jaggernauth _ Jake Jagoda _ Yudh V.S. Jain _ Maria Jakubiak _ Robert Adrien Jalbert _ Gricelda E. James _ Mark Jardim _ Amy
sen _ Prem Nath Jerath _ Farah Jeudy _ Hweidar Jian _ Luis Jimenez Jr. _ Eliezer Jiminez Jr. _ Charles Gregory John _ Nicholas John _ Lt. Col. Dennis
mann Jones _ Donald W. Jones _ Judith Jones _ Mary S. Jones _ Donald Thomas Jones II _ Arthur J. Jones III _ Robert T. Jordan _ Andrew B. Jordan
_ The Rev. Mychal Judge _ Ann Campana Judge _ Paul W. Jurgens _ Thomas E. Jurgens _ Gavkharoy Kamardinova _ Shari Kandell _ Vincent Kane
les H. Karczewski _ William Anthony Karnes _ Douglas G. Karpiloff _ Charles L. Kasper _ Andrew Keith Kates _ John Katsimatides _ Sgt. Robert M.
ul H. Keating _ Leo Russell Keene III _ Brenda Kegler _ Chandler Keller _ Joseph J. Keller _ Peter Rodney Kellerman _ Joseph P. Kellett _ Frederick
ichard Kelly Jr. _ William Hill Kelly Jr. _ Thomas J. Kennedy _ Robert C. Kennedy _ Yvonne Kennedy _ John Keohane _ Ralph Kershaw _ Lt. Ronald
delwal _ SeiLai Khoo _ Satoshi Kikuchihara _ Andrew Jay-Hoon Kim _ Lawrence Don Kim _ Mary Jo Kimelman _ Susan Kim-Hanson _ Heinrich
el Kirby _ Howard (Barry) Kirschbaum _ Glenn Kirwin _ Richard Joseph Klares _ Peter Klein _ Alan D. Kleinberg _ Karen Joyce Klitzman _ Ronald
Ryan Kohart _ Vanessa Lynn Kolpak _ Irina Kolpakova _ Abdoulaye Kone _ Dorota Kopiczko _ Scott Kopytko _ Bojan Kostic _ Danielle Kousoulis
ricia Kuras _ Nauka Kushitani _ Thomas Kuveikis _ Victor Kwarkye _ Kui Fai Kwok _ Angela R. Kyte _ Kathryn L. LaBorie _ Amarnauth Lachhman
K. Lai _ Vincent A. Laieta _ William David Lake _ Franco Lalama _ Chow Kwan Lam _ Lt. Michael Scott Lamana _ Stephen LaMantia _ Amy Hope
chelle B. Lanza _ Ruth Sheila Lapin _ Carol Ann LaPlante _ Ingeborg Lariby _ Robin Blair Larkey _ Judy Larocque _ Christopher Randall Larrabee
es Laurencin _ Stephen James Lauria _ Maria Lavache _ Denis Lavelle _ Jeannine M. LaVerde _ Anna Laverty _ Steven Lawn _ Robert Lawrence _
harles Ledee _ Alan J. Lederman _ Elena Ledesma _ Alexis Leduc _ Lorraine Lee _ Richard Yun Choon Lee _ David S. Lee _ Juanita Lee _ Gary H.
z _ Adriana Legro _ Edward Lehman _ Eric Andrew Lehrfeld _ David Ralph Leistman _ David P. LeMagne _ Joseph A. Lenihan _ John J. Lennon Jr.
s Levi _ Neil D. Levin _ Alisha Caren Levin _ Robert Levine _ Robert M. Levine _ Shai Levinhar _ Daniel C. Lewin _ Adam J. Lewis _ Jennifer Gore
ha Lightbourn-Allen _ Steven B. Lillianthal _ Carlos Lillo _ Craig Damian Lilore _ Arnold A. Lim _ Darya Lin _ Weirong Lin _ Nickie Lindo _ Thomas
ancy Liz _ Harold Lizcano _ Martin Lizzul _ George A. Llanes _ Elizabeth Claire Logler _ Catherine L. Loguidice _ Jerome Robert Lohez _ Michael
ngio _ Chet Louie _ Stuart Louis _ Joseph Lovero _ Sara Low _ Michael W. Lowe _ Garry Lozier _ John Peter Lozowsky _ Charles Peter Lucania _
_ Christopher E. Lunder _ Anthony Luparello _ Gary Lutnick _ William Lutz _ Linda Luzzicone _ Alexander Lygin _ CeeCee Lyles _ Sean Patrick
d Dennis Lynch Jr. _ Robert H. Lynch _ Monica Lyons _ Michael Lyons _ Patrick Lyons _ Nehamon Lyons IV _ Robert F. Mace _ Marianne MacFarlane
agazine _ Charles W. Magee _ Brian Magee _ Joseph V. Maggitti _ Ronald E. Magnuson _ Daniel L. Maher _ Thomas A. Mahon _ William Mahoney
h E. Maloney _ Edward Francis Maloney III _ Gene E. Maloy _ Christian H. Maltby _ Francisco Miguel Mancini _ Joseph Mangano _ Sara Elizabeth
Marcin _ Peter E. Mardikian _ Edward J. Mardovich _ Lt. Charles Margiotta _ Louis Neil Mariani _ Kenneth J. Marino _ Lester Vincent Marino _ Vita
_ Lt. Peter C. Martin _ William J. Martin Jr. _ Lt. Brian E. Martineau _ Robert Gabriel Martinez _ Edward J. Martinez _ Betsy Martinez _ Jose Martinez
son _ Nicholas G. Massa _ Patricia A. Massari _ Michael Massaroli _ Philip W. Mastrandrea Jr. _ Rudolph Mastrocinque _ Joseph Mathai _ Charles
nothy J. Maude _ Charles J. Mauro Jr. _ Nancy T. Mauro _ Dorothy Mauro _ Charles A. Mauro _ Robert J. Maxwell _ Tyrone May _ Renee A. May _
A. McAneney _ Colin Richard McArthur _ John McAvoy _ Ken McBrayer _ Brendan McCabe _ Michael J. McCabe _ Michael Desmond McCarthy _
Juliana Valentine McCourt _ Charles Austin McCrann _ Tonyell McDay _ Matthew T. McDermott _ Joseph McDonald _ Michael McDonnell _ Brian
n McGinly _ Lt. William E. McGinn _ Thomas H. McGinnis _ Michael G. McGinty _ Scott Martin McGovern _ William J. McGovern _ Ann McGovern _
P. McHugh _ Ann M. McHugh _ Denis J. McHugh III _ Michael Edward McHugh Jr. _ Robert G. McIlvaine _ Donald J. McIntyre _ Stephanie McKenna
_ Edmund M. McNally _ Daniel McNeal _ Walter A. McNeil _ Christine Sheila McNulty _ Sean Peter McNulty _ Robert William McPadden _ Terence
an _ William J. Meehan Jr. _ Raymond Meisenheimer _ Manuel Emilio Mejia _ Eskadar Melaku _ Antonio Melendez _ Mary Melendez _ Christopher
olfgang Menzel _ Steve Mercado _ Wesley Mercer _ Ralph Mercurio _ Alan H. Merdinger _ Yamel Merino _ George Merino _ George Merkouris _
kley _ Luis C.R, Mier _ Maj. Ronald D. Milam _ Peter T. Milano _ Gregory Milanowycz _ Lukasz T. Milewski _ Robert Alan Miller _ Douglas C. Miller
enjamin Millman _ Charles M. Mills Jr. _ Ronald Keith Milstein _ Robert Minara _ William G. Minardi _ Louis Minervino _ Wilbert Miraille _ Domenick
loccia Sr. _ Capt. Louis J. Modafferi _ Boyie Mohammed _ Manuel Mojica _ Lt. Dennis Mojica _ Manuel Molina _ Carl Molinaro _ Justin J. Molisani
toya _ Antonio Montoya _ Cheryl Ann Monyak _ Capt. Thomas Moody _ Sharon Moore _ Krishna Moorthy _ Laura Lee Morabito _ Paula Morales _
Morell _ Steven P. Morello _ Vincent S. Morello _ Yvette Nichole Moreno _ Dorothy Morgan _ Richard J. Morgan _ Sanae Mori _ Blanca Morocho _
n Moskal _ Brian Anthony Moss _ Mark Motroni Sr. _ Iouri Moushinski _ Jude Moussa _ Peter C. Moutos _ Damion Mowatt _ Ted Moy _ Christopher
nhall _ Nancy Muniz _ Carlos Mario Munoz _ Theresa Munson _ Robert M. Murach _ Cesar Augusto Murillo _ Marc A. Murolo _ Lt. Raymond E.
Murphy _ Lt. Cmdr. Patrick Jude Murphy _ James Francis Murphy IV _ Robert Murphy Jr. _ John Joseph Murray _ Susan D. Murray _ John J. Murray
rank J. Naples _ Lt. John Napolitano _ Catherine A. Nardella _ Mario Nardone Jr. _ Manika Narula _ Shawn M. Nassaney _ Narender Nath _ Karen
uke Nee _ Peter Negron _ Laura Ann Neira _ David W. Nelson _ Peter Allen Nelson _ Michele Ann Nelson _ Ann Nicole Nelson _ Oscar Nesbitt _
artin Niederer _ Alfonse J. Niedermeyer III _ Frank John Niestadt Jr. _ Gloria Nieves _ Juan Nieves Jr. _ Troy E. Nilsen _ Paul R. Nimbley _ John
_ Brian Novotny _ Brian Nunez _ Jose R. Nunez _ Jeffrey Nussbaum _ James A. Oakley _ Timothy Michael O'Brien _ Michael O'Brien _ Scott O'Brien
arni Pont O'Doherty _ Douglas Oelschlager _ Takashi Ogawa _ Albert Ogletree _ Philip P. Ognibene _ John Ogonowski _ James Andrew O'Grady

Joseph J. Ogren _ Lt. Thomas O'Hagan _ Samuel Oitice _ Capt. William O'Keefe _ Patrick O'Keefe _ Gerald M. Olcott _ Gerald O'Leary _ Christine K. Olson _ Matthew Timothy O'Mahony _ Seamus L. O'Neal _ John P. O'Neill Sr. _ Sean Gordon Corbett O'Neill _ Peter J. O'Neill Jr. _ Betty Ann O _ Ronald Orsini _ Peter K. Ortale _ Jane Orth _ Pablo Ortiz _ Alexander Ortiz _ David Ortiz _ Emilio Ortiz Jr. _ Sonia Ortiz _ Paul Ortiz Jr. _ Masaru _ Michael Otten _ Isidro Ottenwalder _ Michael Ou _ Todd J. Ouida _ Jesus Ovalles _ Peter J. Owens _ Adianes Oyola _ Israel Pabon _ Angel M Palazzolo _ Orio Joseph Palmer _ Frank Palombo _ Alan N. Palumbo _ Christopher M. Panatier _ Dominique Lisa Pandolfo _ Lt. Jonas Martin Panik Paramsothy _ Hardai Parbhu _ James W. Parham _ George Paris _ Debra Paris _ Gye-Hyong Park _ Philip L. Parker _ Michael A. Parkes _ Robert Robert Passananti _ Suzanne H. Passaro _ Dipti Patel _ Avnish Ramanbhai Patel _ Manish K. Patel _ Steven B. Paterson _ James Matthew Patrick _ Sharon Cristina Milan Paz _ Victor Paz-Gutierrez _ Stacey L. Peak _ Richard Pearlman _ Durrell Pearsall Jr. _ Thomas Nicholas Pecorelli _ Thor Salvatore Pepe _ Carl Allen Peralta _ Robert David Peraza _ Jon A. Perconti _ Angela Susan Perez _ Anthony Perez _ Ivan A. Perez _ Alejo Pere William Perry _ Franklin Pershep _ Daniel Pesce _ Michael J. Pescherine _ Jean Hoadley Peterson _ Donald A. Peterson _ William Russel Peterson Phelan _ Eugenia Piantieri _ Ludwig J. Picarro _ Matthew Picerno _ Joseph O. Pick _ Christopher Pickford _ Dennis J. Pierce _ Bernard T. Pietronic Ploger III _ Joseph Plumitallo _ John M. Pocher _ William H. Pohlmann _ Laurence M. Polatsch _ Thomas Polhemus _ Steve Pollicino _ Susan Polli _ Richard Poulos _ Shawn Powell _ Scott Powell _ Brandon Powell _ Gregory Preziose _ Wanda Prince _ Vincent Princiotta _ Kevin Prior _ Everett _ (Retired) Capt. Jack Punches _ Sonia Morales Puopolo _ Hemanth Puttur _ Joseph John Pycior Jr. _ Edward Richard Pykon _ Christopher Qua Rabalais _ Christopher Peter Racaniello _ Leonard Ragaglia _ Eugene J. Raggio _ Laura Marie Ragonese-Snik _ Peter F. Raimondi _ Harry Rain Ramos _ Vishnoo Ramsaroop _ Deborah Ramsaur _ Lorenzo Ramzey _ Lucas Rambousek _ Alfred Todd Rancke _ Adam David Rand _ Jonathan _ Marsha Dianah Ratchford _ David Alan James Rathkey _ William R. Raub _ Gerard Rauzi _ Alexey Razuvaev _ Gregory Reda _ Judith A. Reese _ _ Kevin Reilly _ Joseph Reina Jr. _ Thomas Barnes Reinig _ Frank Bennett Reisman _ Joshua Scott Reiss _ Karen Renda _ John Armand Reo _ R Francis S. Riccardelli _ Rudolph N. Riccio _ AnnMarie Riccoboni _ David Rice _ Eileen M. Rice _ Kenneth F. Rice III _ Cecelia E. Richard _ Lt. Vernor Rimmele _ Theresa Risco _ Rose Mary Riso _ Moises N. Rivas _ Joseph Rivelli Jr. _ Isaias Rivera _ Linda I. Rivera _ Carmen A. Rivera _ Juan W. Riv _ Michael Edward Roberts _ Donald W. Robertson Jr. _ Jeffrey Robinson _ Michell Robotham _ Donald Arthur Robson _ Raymond J. Rocha _ Anto Anthony Rodriguez _ Gregory Rodriguez _ Carmen Milagros Rodriguez _ David B. Rodriguez-Vargas _ Matthew Rogan _ Jean Destrehan Roger _ Rooney _ Eric Thomas Ropiteau _ Angela Rosario _ Aida Rosario _ Mark H. Rosen _ Brooke David Rosenbaum _ Sheryl Lynn Rosenbaum _ Lin David Rosenthal _ Philip M. Rosenzweig _ Daniel Rosetti _ Richard Barry Ross _ Norman Rossinow _ Nicholas P. Rossomando _ Michael Craig Paul Ruback _ Ronald J. Ruben _ Joanne Rubino _ David Ruddle _ Bart J. Ruggiere _ Susan Ann Ruggiero _ Adam K. Ruhalter _ Gilbert Ruiz _ Edward Ryan _ John J. Ryan _ Matthew Ryan _ Tatiana Ryjova _ Christina Sunga Ryook _ Thierry Saada _ Jason Sabbag _ Thomas Sabella _ Sc Saiya _ Marjorie C. Salamone _ John Patrick Salamone _ Juan Salas _ Hernando R. Salas _ Esmerlin Salcedo _ John S. Salerno Jr. _ Rahma Sak Carlos A. Samaniego _ Rena Sam-Dinnoo _ John Paul Sammartino _ James Kenneth Samuel Jr. _ Michael V. San Phillip _ Sylvia San PioResta _ Jr. _ Ayleen J. Santiago _ Kirsten Janssen Santiago _ Maria Theresa Santillan _ Susan G. Santo _ Christopher Santora _ John A. Santore _ Mario S _ Anthony Savas _ Vladimir Savinkin _ Jackie Sayegh Duggan _ John Sbarbaro _ Lt. Col. David Scales _ Robert L. Scandole Jr. _ Michelle Scarpi _ Steven Francis Schlag _ Cmdr. Robert Allan Schlegel _ Jon S. Schlissel _ Karen Helene Schmidt _ Ian Schneider _ Thomas Gerard Schoales Schunk _ Mark E. Schurmeier _ Clarin Shellie Schwartz _ Mark Schwartz _ John Schwartz _ Adriane Victoria Scibetta _ Raphael Scorca _ Randolp _ Matthew Carmen Sellitto _ Michael L. Selves _ Howard Selwyn _ Larry Senko _ Arturo Angelo Sereno _ Frankie Serrano _ Marian H. Serva _ Ale Shahid _ Mohammed Shajahan _ Gary Shamay _ Earl Richard Shanahan _ Cmdr. Dan Frederic Shanower _ Neil G. Shastri _ Kathryn Anne Shatz Shearer _ Linda Sheehan _ Hagay Shefi _ Antoinette Sherman _ John A. Sherry _ Atsushi Shiratori _ Thomas Shubert _ Mark Shulman _ See-W _ Bruce Edward Simmons _ George Simmons _ Don Simmons _ Diane Simmons _ Michael John Simon _ Paul Joseph Simon _ Kenneth A. Sin (Khami) Singh _ Thomas Edison Sinton III _ Peter A. Siracuse _ Muriel F. Siskopoulos _ Joseph M. Sisolak _ John P. Skala _ Francis J. Skidmore L. Small _ Gregg Harold Smallwood _ Joyce Smith _ (Retired) Lt. Col. Gary Smith _ Moira Smith _ Heather Lee Smith _ Karl Trumbull Smith _ K _ Leon Smith Jr. _ Bonnie S. Smithwick _ Rochelle Monique Snell _ Dianne Snyder _ Leonard J. Snyder Jr. _ Christine Anne Snyder _ Astrid Eliz Gregory T. Spagnoletti _ Donald F. Spampinato Jr. _ Thomas Sparacio _ John Anthony Spataro _ Robert Spear Jr. _ Robert Speisman _ Maynard S Srinuan _ Fitzroy St. Rose _ Michael Stabile _ Lawrence T. Stack _ Capt. Timothy Stackpole _ Richard James Stadelberger _ Eric A. Stahlman _ Craig W. Staub _ William V. Steckman _ Eric T. Steen _ William R. Steiner _ Alexander Robbins Steinman _ Edna L. Stephens _ Andrew Stergio Douglas J. Stone _ Jimmy Nevill Storey _ Timothy Stout _ Thomas S. Strada _ James J. Straine Jr. _ Edward W. Straub _ George L. Strauch Jr. _ S Suarez _ Yoichi Sugiyama _ William C. Sugra _ Daniel Suhr _ David M. Sullins _ Patrick Sullivan _ Lt. Christopher P. Sullivan _ Hilario Sumaya Jr. _ D. Sweeney _ Brian Edward Sweeney _ Madeline A. Sweeney _ Kenneth J. Swensen _ Thomas F. Swift _ Derek O. Sword _ Kevin T. Szocik _ G Phyllis Talbot _ Robert R. Talhami _ John Talignani _ Sean Tallon _ Paul Talty _ Maurita Tam _ Rachel Tamares _ Hector Tamayo _ Michael Andre _ Ron Tartaro _ Leonard Taylor _ Michael M. Taylor _ Donnie Brooks Taylor _ Hilda E. Taylor _ Sandra Taylor _ Maj. Kip P. Taylor _ Lorisa Ceylon T _ Goumatie Thackurdeen _ Harshad S. Thatte _ Michael Theodoridis _ Thomas Francis Theurkauf Jr. _ Lesley Thomas O'Keefe _ Glenn Thompso _ Nichola A. Thorpe _ Sgt. Tamara Thurman _ Sal E. Tieri Jr. _ John Patrick Tierney _ William Randolph Tieste _ Kenneth F. Tietjen _ Steven Edwa _ Alicia N. Titus _ John J. Tobin _ Richard J. Todisco _ Lt. Cmdr. Otis Vincent Tolbert _ Vladimir Tomasevic _ Stephen K. Tompsett _ Thomas Tong P. Travers Jr. _ Felicia Traylor-Bass _ James A. Trentini _ Mary B. Trentini _ Lisa L. Trerotola _ Karamo Trerra _ Michael T. Trinidad _ Francis Jose Tung _ Simon James Turner _ Donald Joseph Tuzio _ Robert T. Twomey _ Jennifer Tzemis _ John G. Ueltzhoeffer _ Tyler Ugolyn _ Michael A. Uli Ivan Vale _ Felix Antonio Vale _ Benito Valentin _ Santos Valentin Jr. _ Carlton F. Valvo II _ Pendyala Vamsikrishna _ Erica Van Acker _ Kenneth W Varadhan _ David Vargas _ Scott C. Vasel _ Azael I. Vasquez _ Santos Vasquez _ Lt. Cmdr. Ronald James Vauk _ Arcangel Vazquez _ Peter A. V Gilbert Vianna _ Robert Vicario _ Celeste Torres Victoria _ Joanna Vidal _ Joseph Vincent Vigiano _ John T. Vigiano II _ Frank J. Vignola Jr. _ Joseph _ Lynette D. Vosges _ Garo H. Voskerijian _ Alfred Vukosa _ Gregory Wachtler _ Lt. Col. Karen Wagner _ Mary Alice Wahlstrom _ Honor Elizabeth _ Peter Wallace _ Mitchel Wallace _ Lt. Robert F. Wallace _ Jeanmarie Marie Wallendorf _ Matthew Blake Wallens _ Meta Waller _ John Wallice Jr. _ G. Warner _ Derrick Washington _ Charles Waters _ James T. Waters Jr. _ Capt. Patrick Waters _ Kenneth Watson _ Michael H. Waye _ Walter E. We Weinstein _ Simon Weiser _ David Martin Weiss _ David Thomas Weiss _ Vincent Wells _ Deborah A. Welsh _ Timothy Welty _ Christian Hans Rud White _ Malissa White _ James Patrick White _ Edward White _ Wayne White _ Leonard Anthony White _ Sandra White _ Adam S. White _ Kenneth Lenz Wieman _ Jeffrey David Wiener _ William J. Wik _ Alison Marie Wildman _ Lt. Glenn Wilkinson _ Ernest M. Willcher _ John Willett _ Louie Anth Williams _ Kevin M. Williams _ Louis Calvin Williams III _ Crossley Williams Jr. _ Lt. John P. Williamson _ William E. Wilson _ Cynthia Wilson _ Donna _ Michael Wittenstein _ Christopher Wodenshek _ Martin P. Wohlforth _ Katherine S. Wolf _ Yuk Ping Wong _ Jenny Low Wong _ Yin Ping Wong _ Jennif _ John B. Works _ Martin M. Wortley _ Rodney J. Wotton _ William Wren _ Sandra Wright _ Neil R. Wright _ John Wright _ Naomi Yajima _ Jupiter Yamber Yee _ Kevin Wayne Yokum _ Edward Phillip York _ Raymond York _ Kevin Patrick York _ Suzanne Youmans _ Donald McArthur Young _ Edmon Jr. _ Robert Alan Zampieri _ Christopher R. Zarba _ Ira Zaslow _ Kenneth A. Zelman _ Abraham J. Zelmanowitz _ Martin Zempoaltecatl _ Zhe Zeng _ Prokopios Paul Zois _ Joseph J. Zuccala _ Andrew S. Zucker _ Igor Zukelman (List courtesy of CNN.com as of March 2002. ©2001 Cable News Network)

Olender _ Linda Oliva _ Edward K. Oliver _ Leah E. Oliver _ Jeffrey James Olsen _ Eric T. Olsen _ Steven J. Olson _ Maureen L. Olson _ Barbara
ichael C. Opperman _ Christopher Orgielewicz _ Margaret Quinn Orloske _ Virginia A. Ormiston-Kenworthy _ Ruben Ornedo _ Kevin O'Rourke _
, Robert W. O'Shea _ Patrick J. O'Shea _ Elsy Carolina Osorio Oliva _ James Robert Ostrowski _ Timothy F. O'Sullivan _ Jason Douglas Oswald _
n _ Roland Pacheco _ Michael B. Packer _ Spc. Chin Sun Pak _ Deepa K. Pakkala _ Jeffrey M. Palazzo _ Thomas Anthony Palazzo _ Richard
Pansini _ John M. Paolillo _ Edward J. Papa _ _ Salvatore Papasso _ James Pappageorge _ Marie Pappalardo _ Vinod K. Parakat _ Vijayashanker
t Parks Jr. _ Hasmukhrai Parmar _ Robert Parro_ Diane Parsons _ Leobardo Lopez Pascual _ Michael J. Pascuma Jr. _ Jerrold Paskins _ Horace
uel Patrocino _ Bernard E. Patterson _ Maj. Clifford Patterson Jr. _ Cira Marie Patti _ Robert Edward Pattison _ James Robert Paul _ Patrice Paz
Pedicini _ Todd D. Pelino _ Michel Adrian Pelletier _ Anthony Peluso _ Angel R. Pena _ Jose D. Pena _ Robert B. Penniger _ Richard A. Penny _
ncy E. Perez _ Angel Perez Jr. _ Berinthia Berenson Perkins _ Joseph Perroncino _ Edward J. Perrotta _ Emelda Perry _ Lt. Glenn Perry _ John
, Peterson _ Mark Petrocelli _ Lt. Philip Petti _ Glen Pettit _ Dominick Pezzulo _ Kaleen E. Pezzuti _ Lt. Kevin Pfeifer _ Tu-Anh Pham _ Lt. Kenneth
cholas P. Pietrunti _ Theodoro Pigis _ Susan Elizabeth Ancona Pinto _ Joseph Piskadlo _ Christopher Todd Pitman _ Joshua Piver _ Robert Riis
g. Darin Howard Pontell _ Joshua Poptean _ Giovanna Porras _ Anthony Portillo _ James Edward Potorti _ Daphne Pouletsos _ Stephen Poulos
Proctor III _ Carrie B. Progen _ David Lee Pruim _ Richard Prunty _ John F. Puckett _ Robert D. Pugliese _ Edward F. Pullis _ Patricia Ann Puma
sh _ Lars P. Qualben _ Lincoln Quappe _ Beth A. Quigley _ Patrick J. Quigley VI _ Lt. Michael Quilty _ Ricardo Quinn _ James F. Quinn _ Carol
sa Joy Raines _ Ehtesham U. Raja _ Valsa Raju _ Edward Rall _ Lukas Rambousek _ Julio Fernandez Ramirez _ Maria Isabel Ramirez _ Harry
dall _ Srinivasa Shreyas Ranganath _ Anne T. Ransom _ Faina Rapoport _ Robert Arthur Rasmussen _ Amenia Rasool _ Roger Mark Rasweiler
s M. Regan _ Donald J. Regan _ Lt. Robert M. Regan _ Christian Regenhard _ Howard Reich _ Gregg Reidy _ Timothy E. Reilly _ James B. Reilly
C. Rescorla _ John Resta _ Martha Reszke _ David E. Retik _ Todd H. Reuben _ Eduvigis Reyes _ Bruce A. Reynolds _ John Frederick Rhodes _
d _ Venesha Richards _ Gregory Richards _ Michael Richards _ Claude D. Richards _ Alan Jay Richman _ John M. Rigo _ James Riley _ Frederick
avid E. Rivers _ Joseph R. Riverso _ Paul V. Rizza _ John Frank Rizzo _ Stephen L. Roach _ Joseph Roberto _ Leo A. Roberts _ Michael Roberts
usto Tome Rocha _ Laura Rockefeller _ John Michael Rodak _ Antonio Jose Carrusca Rodrigues _ Richard Rodriguez _ Marsha A. Rodriguez _
Barbara Rogers _ Scott Rohner _ Keith Roma _ Joseph M. Romagnolo _ Efrain Romero Sr. _ Elvin Santiago Romero _ James A. Romito _ Sean
enbaum _ Mark Louis Rosenberg _ Lloyd Daniel Rosenberg _ Andrew I. Rosenblum _ Joshua M. Rosenblum _ Joshua A. Rosenthal _ Richard
g _ Mark Rothenberg _ Donna M. Rothenberg _ James M. Roux _ Nick Rowe _ Edward Veld Rowenhorst _ Judy Rowlett _ Timothy A. Roy Sr. _
n P. Russell _ Robert Errol Russell _ Steven Harris Russin _ Wayne Alan Russo _ Lt. Michael Russo Sr. _ William R. Ruth _ Jonathan S. Ryan _
aber _ Charles E. Sabin _ Joseph Thomas Sacerdote _ Jessica L. Sachs _ Francis John Sadocha _ Jude Elie Safi _ Brock Safronoff _ Edward
hard L. Salinardi _ Wayne J. Saloman _ Nolbert Salomon _ Catherine Patricia Salter _ Frank Salvaterra _ Paul R. Salvio _ Samuel R. Salvo Jr. _
anay-Perafiel _ Jesus Sanchez_ Jacquelyn P. Sanchez _ Alva J. Sanchez _ Eric Sand _ Stacey Leigh Sanders _ Herman Sandler _ James Sands
_ Rufino Conrado F. Santos III _ Rafael Humberto Santos _ Victor Saracini _ Kalyan K. Sarkar _ Paul F. Sarle _ Gregory Saucedo _ Susan Sauer
ennis Scauso _ John A. Schardt _ John G. Scharf _ Fred Claude Scheffold Jr. _ Angela Susan Scheinberg _ Scott M. Schertzer _ Sean Schielke
sa DiNardo Schorpp _ Frank G. Schott _ Gerard P. Schrang _ Jeffrey Schreier _ John T. Schroeder _ Susan Lee Kennedy Schuler _ Edward W.
_ Janice Scott _ Christopher J. Scudder _ Arthur Warren Scullin _ Michael Seaman _ Margaret Walier Seeliger _ Carlos Segarra _ Jason Sekzer
inova _ Adele C. Sessa _ Sita Sewnarine _ Karen Lynn Seymour-Dietrich _ Davis Sezna Jr. _ Thomas Sgroi _ Jayesh Shah _ Khalid Mohammad
rbara A. Shaw _ Jeffrey J. Shaw _ Robert John Shay Jr. _ Joseph Patrick Shea _ Daniel James Shea _ Robert Michael Shearer _ Mary Kathleen
um _ Johanna Sigmund _ Dianne T. Signer _ Gregory Sikorsky _ Stephen Gerard Siller _ David Silver _ Craig A. Silverstein _ Nasima H. Simjee
thur Simon _ Marianne Simone _ Barry Simowitz _ Jane Louise Simpkin _ Jeff Simpson _ Cheryle Sincock _ Roshan R. Singh _ Khamladai K.
yena C. Skinner _ Paul A. Skrzypek _ Christopher Paul Slattery _ Vincent Slavin _ Robert Sliwak _ Paul K. Sloan _ Stanley Smagala Jr. _ Wendy
mith _ Daniel Laurence Smith _ James Gregory Smith _ Rosemary Smith _ Sandra Fajardo Smith _ Jeffrey Randall Smith _ Catherine T. Smith
Sohan _ Ruben Solares _ Naomi Leah Solomon _ Daniel W. Song _ Mari-Rae Sopper _ Michael Sorresse _ Fabian Soto _ Timothy P. Soulas _
e Jr. _ Robert Andrew Spencer _ George E. Spencer III _ Mary Rubina Sperando _ Frank J. Spinelli _ William E. Spitz _ Joseph P. Spor _ Saranya
y M. Stajk _ Corina Stan _ Alexandru Liviu Stan _ Mary D. Stanley _ Anthony M. Starita _ Jeffrey Stark _ Derek J. Statkevicus _ Patricia Statz
_ Andrew Stern _ Norma Lang Steuerle _ Martha Stevens _ Michael J. Stewart _ Richard H. Stewart Jr. _ Sanford M. Stoller _ Lonny J. Stone
, Strauss _ Edward T. Strauss _ Sgt. Maj. Larry L. Strickland _ Steven Strobert _ Xavier Suarez _ David S. Suarez _ Ramon Suarez _ Benjamin
Joseph Suozzo _ Colleen Supinski _ Robert Sutcliffe _ Selina Sutter _ Claudia Suzette Sutton _ John F. Swaine _ Kristine M. Swearson _ Brian
ejnberg _ Norbert Szurkowski _ Harry Taback _ Joann Tabeek _ Norma C. Taddei _ Michael Taddonio _ Keiji Takahashi _ Keiichiro Takahashi _
ccio _ Rhondelle Cherie Tankard _ Michael A. Tanner _ Dennis Taormina Jr. _ Kenneth Joseph Tarantino _ Allen Tarasiewicz _ Michael C. Tarrou
Darryl A. Taylor _ Sandra D. Teague _ Karl W. Teepe _ Paul Tegtmeier _ Anthony Tempesta _ Dorothy Temple _ Brian Terrenzi _ Lisa Marie Terry
Thompson _ Capt. William Harry Thompson _ Brian T. Thompson _ Nigel Bruce Thompson _ Perry Anthony Thompson _ Eric Raymond Thorpe
_ Scott C. Timmes _ Michael Tinley _ Jennifer Marie Tino _ Robert Tipaldi _ John J. Tipping II _ David Tirado _ Hector Tirado Jr. _ Michelle Titolo
Eduardo Torres _ Doris Torres _ Amy E. Toyen _ Christopher M. Traina _ Daniel Patrick Trant _ Abdoul Karim Traore _ Glenn J. Travers _ Walter
bino _ Gregory J. Trost _ Willie Q. Troy _ William P. Tselepis Jr. _ Zhanetta Tsoy _ Michael Patrick Tucker _ Lance Richard Tumulty _ Ching Ping
nathan Uman _ Anil S. Umarkar _ Alan V. Upton _ Diane Maria Urban _ John Damien Vaccacio _ Bradley H. Vadas _ Mayra Valdes-Rodriguez _
ken _ Richard Bruce Van Hine _ Daniel M. Van Laere _ Edward Raymond Vanacore _ Jon C. Vandevander _ Frederick Varacchi _ Gopalakrishnan
ankara S. Velamuri _ Jorge Velazquez _ Lawrence Veling _ Anthony M. Ventura _ David Vera _ Loretta A. Vero _ Christopher Vialonga _ Matthew
do _ Chantal Vincelli _ Melissa Vincent _ Lawrence Joseph Virgilio _ Francine A. Virgilio _ Joseph G. Visciano _ Joshua Vitale _ Maria Percoco Vola
Gabriela Waisman _ Wendy Wakeford _ Courtney Walcott _ Victor Wald _ Kenneth E. Waldie _ Benjamin Walker _ Glen James Wall _ Roy Wallace
alsh _ Barbara P. Walsh _ Jeffrey P. Walz _ Weibin Wang _ Lt. Michael Warchola _ Timothy Ray Ward _ Stephen G. Ward _ James A. Waring _ Brian
odd Weaver _ Nathaniel Webb _ William M. Weems _ Joanne Flora Weil _ Steven Weinberg _ Michael Weinberg _ Scott Jeffrey Weingard _ Steven
mers _ Ssu-Hui Wen _ John J. Wenckus _ Oleh D. Wengerchuk _ Whitfield West _ Peter M. West _ Meredith L. Whalen _ Eugene Whelan _ John S.
_ Olga Kristin Gould White _ Staff Sgt. Maudlyn White _ Leanne Marie Whiteside _ Mark Whitford _ Leslie A. Whittington _ Michael Wholey _ Mary
ams _ Maj. Dwayne Williams _ Lt. Cmdr. David Lucian Williams _ Brian Patrick Williams _ Candace Lee Williams _ Deborah Lynn Williams _ David
, David H. Winton _ Glenn J. Winuk _ Thomas Francis Wise _ Alan Wisniewski _ Frank T. (Paul) Wisniewski _ David Wiswall _ Sigrid Charlotte Wiswe
ng _ Siu Cheung Wong _ Brent James Woodall _ Marvin Roger Woods _ James J. Woods _ Patrick Woods _ Richard H. Woodwell _ Capt. David Wooley
D. Yamnicky Sr. _ Suresh Yanamadala _ Vicki C. Yancey _ Shuyin Yang _ Matthew David Yarnell _ Myrna Yaskulka _ Shakila Yasmin _ Olabisi Layeni
_ Lisa Young _ Barrington L. Young _ Jacqueline Young _ Elkin Yuen _ Joseph Zaccoli _ Adel A. Zakhary _ Arkady Zaltsman _ Edwin J. Zambrana
cott Zeplin _ Jie Yao Justin Zhao _ Yuguang Zheng _ Ivelin Ziminski _ Michael J. Zinzi _ Charles A. Zion _ Julie Lynne Zipper _ Salvatore J. Zisa

Lamentation: 9/11 was published by Ruder Finn Press to honor the many lives that were touched by the September 11 disaster.

100% of the profits from the sale of **Lamentation: 9/11** will be donated to the SEEDS OF PEACE for a new program to bring American and Arab teenagers together to create a common understanding between our two cultures. The SEEDS OF PEACE is a nonprofit, nonpolitical organization that brings teenagers from regions of conflict together to develop the leadership capabilities required to end the cycles of violence. The program has brought together teenagers from Israel and the Arab nations, the Balkans and, most recently, India and Pakistan. It is our hope that these friendships will provide the seeds for an everlasting peace.

RUDER FINN PRESS

301 East 57th Street
New York, New York 10022